ADVERTISING SHITS IN YOUR HEAD

Strategies for Resistance

VYVIAN RAOUL & MATT BONNER

Advertising Shits in Your Head: Strategies for Resistance
Vyvian Raoul & Matt Bonner

This edition © 2019 PM Press
ISBN: 978-1-62963-574-3 (paperback)
ISBN: 978-1-62963-701-3 (hardcover)

Library of Congress Control Number: 2018931526

Printed in the UK by Calverts Ltd, a workers' co-operative · calverts.coop

Front cover image by Matt Bonner
Cover and interior graphic design by Matt Bonner · revoltdesign.org

10 9 8 7 6 5 4 3 2 1

PM Press
PO Box 23912
Oakland, CA 94623
www.pmpress.org

This edition first published in Canada in 2019 by Between the Lines
401 Richmond Street West, Studio 277, Toronto, Ontario
M5V 3A8, Canada • www.btlbooks.com

ISBN: 978-1-77113-386-9 (Between the Lines paperback)
Canadian cataloguing information is available from
Library and Archives Canada

CONTENTS

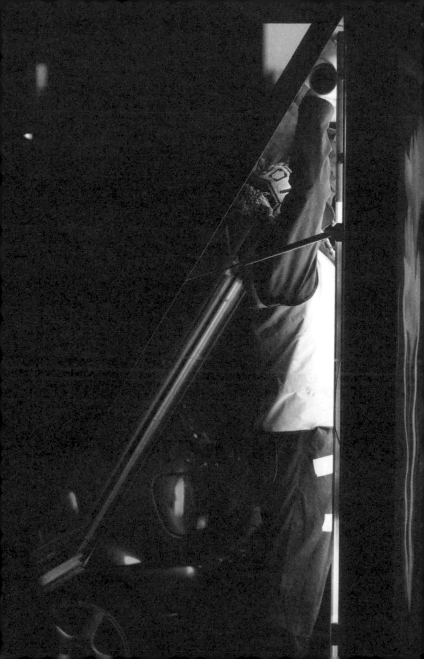

"The constant imposition of advertising in front of our eyes is an oppressive, dictatorial and violent act. Subvertising reacts to this visual pollution with an equally violent and direct aesthetic, without asking for permission or waiting for consensus. Removing, replacing and defacing advertising is an act of civil disobedience that is both legally and morally defensible."

Hogre

INTRODUCTION

BY JOSH MACPHEE

"Excuse me, sir, which direction is Michigan Avenue?"

It's 8 a.m., and we're standing in a bus shelter in front of Chicago City Hall replacing a seven-foot-tall advertisement with a giant poster of then-mayor Richard M. Daley which squarely blames him for turning public housing into development schemes for the rich. My hands are shaking from nervousness, and the last thing I expected was to be asked for directions. But that's the amazing thing about neon-orange vests—they make you look like you belong just about anywhere, and they make what you are doing most definitely official business.

One of the most important things to take away from this book is the idea that everyone can—and should—exercise some control over their visual landscape. And it may not be as hard to do as it initially seems. While many of the ad hacks included here were done by people with a lot of experience, I certainly had never switched out a bus shelter advertisement before that morning back in 2005. We changed almost two dozen large-format advertisements throughout the city in a couple hours, and none of us were well-seasoned subvertisers. Our work was part of a larger campaign attacking the government and real estate developers for decimating the lives and communities of Chicago public housing residents. We also saw the work as a critique of the broader move literally selling the ground out from under poor and working

people's feet while simultaneously signing huge contracts with companies like global advertising giant JCDecaux to allow them to blanket the city with a massive increase in corporate messaging.

———————

There is no doubt that advertising is a form of pollution and corporations are shitting in our heads. It is one of the main social forces that convince us that the status quo is both natural and inevitable and that nothing can be done to change it. More than the messaging of any particular billboard, subway poster, or corporate commercial wrapping a city bus, the overarching ideology of advertising is that the best—and increasingly only— use for any form of shared space is as a conveyor belt bringing us from one point of purchase to another. A walk through Times Square in New York City exposes how dystopian this can get. Even the ground and sky are littered with messaging, with advertising cacophony taking over more than two-thirds of what the eye can see, never mind sound, smell, and physical encroachments. It's not a huge leap to image that as things continue on their current trajectory, much of our world will look and feel like this.

I often use the term "shared" space instead of the more popular "public" because it is time we interrogate our dependence on the binary conception of public vs. private. First, it's increasingly foggy as to what is public and what is private anymore. Almost all space is privatized to some extent. In addition, what does *public* actually mean? A public is a group of people with shared beliefs and ideology. But if you attempt to unpack what everyone sharing a common space have in common, it is that they are all subjects of an external sovereign, the state. In the twenty-first century, public

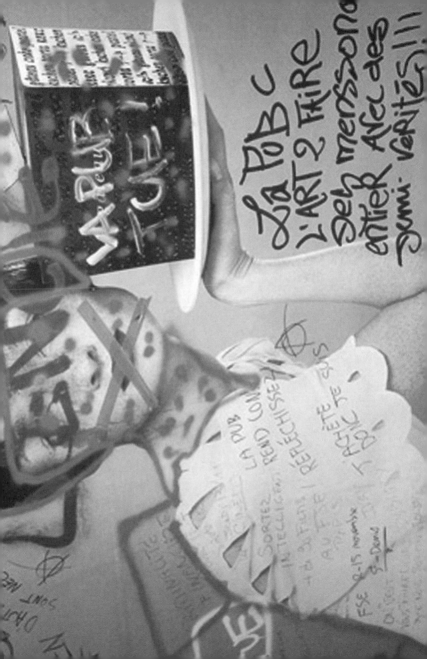

space is space managed by the state. And most people on our planet live in contexts where they have little to no control over the state, and the apparatus that administers our lives is increasingly unaccountable to the subjects it supposedly represents. So *public* no longer means what it is commonly understood to mean. How can public space be public if it is almost wholly constituted by a power beyond our reach and control?

───────────

Unfortunately in our society the social relations and economic conditions of capitalism are so conceptually dominant that they infect all of our thoughts and actions. In the early 2000s, street art deftly moved from being an interesting and quirky form of opening up space to think and wonder on the street—What is that pink elephant doing there? How come everywhere I look it says, "You Are Beautiful?"—to just another way of advertising. Whether by artists looking for a shortcut to gallery careers or corporations mimicking and recuperating "street" aesthetics, the need to lead the viewer to a commercial exchange hollows out any other possible interpretation of the work. Subvertising is no different. We are so trained by years of looking at our commercialized landscape, that it's likely most people read hacked ads as the real thing, and fail to fully process any detournement. This is especially true for hacks that mimic the design, aesthetic, and logotypes of the original. When a company like McDonald's has invested billions of dollars over a seventy-year stretch to ensure that their golden arches mean very specific things, it seems woefully naive to think that a comparative handful of "McMurder" subvertising exploits could ever affect the dominant reading. More likely viewers of a McMurder or Murder King T-shirt simply get a subconscious urge to eat french fries.

It's for this reason that I find Jordan Seiler's PublicAdCampaign one of the most convincing examples in this book. Seiler started the campaign with the idea of replacing advertisements with art, and I even went out on one of the early group takeovers, where he provided teams of us with buckets of white paint to buff out adverts across Lower Manhattan. Unfortunately he also organized a second set of teams to cover over our buffs with their artwork, which I felt strongly bound the action up in the thorny political issues I've discussed. But Seiler evolved the work, and democratized the concept both by "mass-producing" keys for anyone to use to access ad spaces, but also by simply replacing advertisements with his bold, largely black-and-white abstract and op-art graphics. Although extremely simple in form and seemingly contentless, his refusal to replace the advertisements with other direct messaging—be it called art or not—may ultimately say more than any didactic ad hack can. Some have critiqued Seiler's work as not going far enough, and maybe there is some truth to that—the palatability of his graphic compositions ultimately allows them to be absorbed into the overarching and dominant matrix of our shared space as solely a platform for advertising. So they are read as commercial messages, even if it remains unclear what they are selling.

One of the groups that have best challenged this matrix, but isn't focussed on here in the book, is the StopPub movement in France. Born in the early 2000s, groupings taking on the name of StopPub or Anti-Pub (Pub is short for publicité, or advertising) decided to take more extreme measures against the encroachment of advertising into daily life. One of the most ambitious projects taken on under the StopPub banner was an October 2003 action where seven groups of twenty to twenty-five people converged on

the Paris Metro system with paint, markers, and paste. Overnight they completely defaced and destroyed advertisements throughout the system, obliterating corporate messaging from many stations all together. Unlike Seiler's more genteel and nuanced critique, there was no possibility of confusion here: all advertising must be destroyed.

––––––––

Back to the book in your hand. It would behoove all of us to read it, and closely. We need to seriously think about the increasingly intense position advertising plays in our lives. It doesn't really matter if you intend to become an ad hacker or not. While the bus shelter ad switch I began this introduction with went off without a hitch, not all of my anti-advertising exploits have been so successful. An earlier attempt to use paint bombs to cover over an anti-abortion billboard left me completely coated in grey paint and the billboard largely untouched.

Everyone has different skill sets. I have no intention of becoming a bicycle mechanic, but I do know how to change a tire. Likewise, you don't need to climb fifty feet onto a billboard to help take back our shared visual environment. Pushing this discussion outward to broader and broader groups of people is essential. There are also many interventionist tactics with very low barriers to entry, like keeping a marker in your pocket and crossing out ads you find offensive, or putting up small stickers that challenge the dominant narrative. The first step to having a say in your visual space is literally having your say.

As Hugh Masekela once said, "All that remains to do is to do."

Watney Market

#ADHACKMANIFESTO

1. ADVERTISING SHITS IN YOUR HEAD
IT IS A FORM OF VISUAL AND PSYCHOLOGICAL POLLUTION.

2. REMOVING/REPLACING/DEFACING ADVERTISING IS NOT VANDALISM
IT IS AN ACT OF TIDYING UP THAT IS BOTH LEGALLY & MORALLY DEFENSIBLE.

3. THE VISUAL REALM IS A PUBLIC REALM IT IS PART OF THE COMMONS
IT BELONGS TO EVERYONE, SO NO-ONE SHOULD BE ABLE TO OWN IT.

4. OUTDOOR ADVERTISING CAN AND SHOULD BE BANNED
SAO PAULO DID IT IN 2007, & GRENOBLE FOLLOWED SUIT IN 2015.

AdHACKMANIFESTO

ADVERTISING

HITS IN YOUR HEAD

IS A FORM OF VISUAL AND PSYCHOLOGICAL POLLUTION.

REMOVING/REPLACING/DEFACING ADVERTISING

IS NOT VANDALISM

IS AN ACT OF TIDYING UP THAT IS BOTH LEGALLY & MORALLY DEFENSIBLE.

THE VISUAL REALM IS A

PUBLIC REALM

IT IS PART OF THE COMMONS

BELONGS TO EVERYONE, SO NO-ONE SHOULD BE ABLE TO OWN IT.

OUTDOOR ADVERTISING

CAN AND SHOULD BE

BANNED

SÃO PAULO DID IT IN 2007, & GRENOBLE FOLLOWED SUIT IN 2015.

PART 1

ADVERTISING
SHITS IN YOUR HEAD

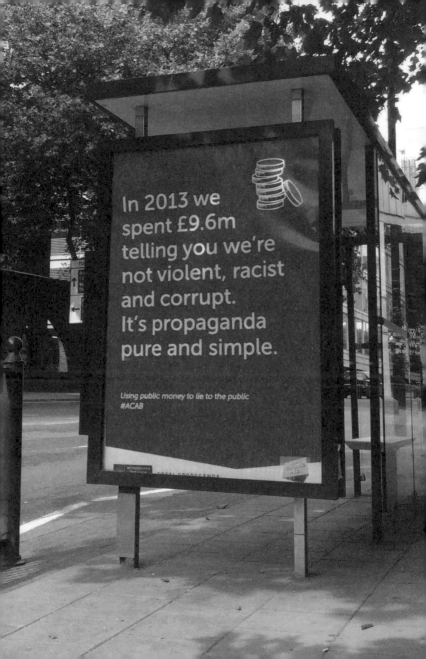

1
PR-OPAGANDA

> *"20th century advertising is the most powerful and sustained system of propaganda in human history and its cumulative cultural effects, unless quickly checked, will be responsible for destroying the world as we know it. As it achieves this it will be responsible for the deaths of hundreds of thousands of non-western peoples and will prevent the peoples of the world from achieving true happiness. Simply stated, our survival as a species is dependent upon minimizing the threat from advertising and the commercial culture that has spawned it."[1]*
>
> Sut Jhally

The modern subvertising movement has consumerism as its target. Many practitioners present their work as explicitly anticapitalist and almost all object to outdoor advertising as a form of propaganda. Jordan Seiler of Public Ad Campaign notes how ingrained in our collective consciousness this system of propaganda has become, claiming that our acceptance is

> *"testament to how much advertising in general has actually infused itself into our lives and we consider it to be a medium that is inescapable and just inherently a part of the capitalist system"[2]*

In the section of the Brandalism website titled "Why Brandalise?" the authors specifically cite the system of propaganda we euphemistically call public relations, which they claim advances unsustainable economic growth.[3]

But what does it mean to categorise outdoor advertising as propaganda?

BAD WORDS?

> *"Propaganda got to be a bad word because of the Germans using it, so what I did was to try and find some other word, so we found the words Counsel on Public Relations."*[4]
>
> Edward Bernays

Before public relations was called public relations, it was called propaganda. It is no small irony that propaganda got such a bad name from its wartime usage—in mobilising millions to the deadliest conflagration the world had seen—that the word itself had to be spun. The man responsible for effecting the name-change was Edward Bernays, the most famous practitioner of the industry he invented. But before he'd changed the name, Bernays wrote a book on the practice, entitled *Propaganda*, which was at once a beginner's guide to public relations and propaganda for propaganda.

Although the name changed, public relations retains its essential definition: effort directed systematically toward gaining support for an opinion or a course of action. In *Propaganda*, Bernays explains: "The mechanism by which ideas are disseminated on a large scale is propaganda, in the broad sense of an organised effort to spread a particular belief or doctrine."[5] It only became a dirty word because the Germans used it, but it is exactly the same method. Bernays also used examples of how propaganda is necessary to bring about the changes in public opinion that allow, for example, dangerous chemicals in food to be outlawed.[6] Propaganda is not inherently good or bad; it's what you do with it that counts.[7]

Indeed, for Bernays, the conspicuous manipulation of the masses by means of propaganda was seen not just as inevitable and benign, but important and necessary. It is a claim that rests on the idea that the mass of people—the public—are dangerous when left to their own devices, but also that certain individuals—and only these individuals—are talented enough to guide the rest. Where subvertising activists posit outdoor advertising as undemocratic (in that there is no collective control over it), Bernays suggests that public relations are vital part of a democratic society. The meaning of the word "democracy" is highly contested, but in Bernays's schema it almost eats itself:

> *"The conscious and intelligent manipulation of the organized habits and opinions of the masses is an important element in democratic society. Those who manipulate this unseen mechanism of society constitute an invisible government which is the true ruling power of the country. We are governed, our minds moulded, our tastes formed, our ideas suggested, largely by men we have never heard of. This is a logical result of the way in which our democratic society is organized. Vast numbers of human beings must co-operate in this manner if they are to live together as a smoothly functioning society."[8]*

For Bernays, a smoothly functioning society was one marshaled around consumption;[9] he viewed the American way of life and the capitalist system of production as completely entwined. Though he occasionally uses examples of other ways that propaganda can be used, Bernays has a special place for propaganda that promotes what he claims to be the civilising influence of capitalism. He also argues that good advertising is not simply propaganda for an individual product, or even for an individual company, but for the entire system of consumption.[10]

Subvertisers claim that this conscious, conspicuous manipulation of the masses—essentially unchanged since Bernays—places the emphasis on passive consumption over active political participation.

THE EDGE OF APOCALYPSE

It is further claimed that a system that demands nothing more than unquestioned consumption may be taking a devastating toll in terms of environmental destruction. Subvertisers follow Sut Jhally (quoted at the start of this chapter) when they claim that advertising is fuel for a system of exponential growth and ever-increasing consumption on a finite planet. Brandalism performed their largest ad takeover to date—by installing over six hundred posters in bus stop advertising spaces—in protest at the corporate capture of the COP 21 climate talks in Paris. Bill Posters of Brandalism explains their targeting of the climate talks:

> *"We are taking their spaces back because we want to challenge the role advertising plays in promoting unsustainable consumerism. Because the advertising industry force feeds our desires for products created from fossil fuels, they are intimately connected to causing climate change. As is the case with the climate talks and their corporate sponsored events, outdoor advertising ensures that those with the most money are able to ensure that their voices get heard above all else."[11]*

It's not that propaganda, public relations, outdoor advertising, or the intersections of all three are inherently evil. It's just that the system of production they have been so adept at promoting throughout the twentieth and twenty-first centuries is responsible

for economic crises, resource wars, widening inequality, and, perhaps most alarmingly, environmental destruction on a global scale.

Subvertisers can justifiably claim that propaganda may, once again, be marshaling millions to their deaths.

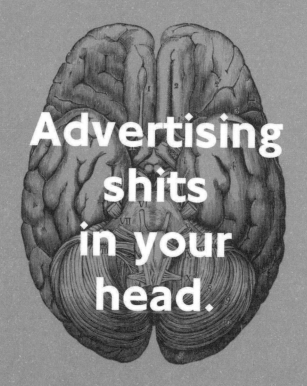

Advertising shits in your head.

It is a form of visual and psychological pollution.

#AdvertisingShitsInYourHead

#ADHACK MANIFESTO

SUBVERTISERS
FOR LONDON
PUBLIC SPACE MATTERS

2

ADVERTISING SHITS IN YOUR HEAD

"Advertising shits all over and dominates our culture. It is a visceral, powerful form of pollution that not only affects our common public and cultural spaces, but also our deeply private intimate spaces. Advertisers want your 'brain time'—to shit in your head without your knowledge. We want to stop them."[12]

Bill Posters—Brandalism

VISUAL POLLUTION

A common theme amongst subvertising activists is to conceptualise advertising as a form of pollution. Bill Posters refers to it as pollution in his 2014 article "Advertising Shits in Your Head,"[13] and Special Patrol Group's second Ad Hack Manifesto claim is that advertising is "a form of visual and psychological pollution." This echoes artist and subvertiser Darren Cullen's sentiments in an interview about subvertising, when he called removing or replacing advertising "an act of tidying up."[14] When Sao Paolo Mayor Gilberto Kassab implemented the Clean City Law in 2007, it too labelled outdoor adverts a form of "visual pollution."

It is certainly true that the average city dweller is confronted by what the industry terms out-of-home (OOH) advertising at a dazzling rate. The average commuter is exposed to more than 130

adverts featuring more than 80 different products in a 45-minute metropolitan transit journey; in an entire day, residents of a capital city are likely to see around 3,500 commercial messages.[15]

Subvertisers claim that—just as with other pollutants—the presence of advertising in the environment has harmful effects.

YOUR EYES READ THIS SILENTLY

Perhaps one reason a comparison with pollution is apt is the way that advertising can accumulate in the environment—a sort of commercial clutter. And it is as background environmental accumulation that advertising can be most harmful.

Some advertisers declare that the affect of advertising is benign,[16] but also that it is a powerful form of persuasion: on one hand, nobody notices outdoor adverts anyway, and, on the other, it is a multi-billion-dollar industry that helps to influence our decisions.[17] The reason it's possible to claim that "99% of adverts make little or no impact"[18] and still sell advertising at an ever-increasing rate is that it is precisely as background noise that adverts have their most powerful effect.

Advertising researcher Dr Robert Heath has proven that advertising works on a subconscious level, meaning it works on us without high levels of attention. He posits a "Low Attention Processing Model," which shows that advertising has an effect on us even when we don't actively notice it or aren't able to consciously recall it.[19] Furthermore, he has proven that advertising works on an emotional rather than an intellectual level, meaning that even those who are conscious of advertising's false promises can still be affected through their feelings. The only way to avoid this

subconscious affect is to avoid advertising altogether; as subvertisers and advertisers alike point out, that is almost impossible.

WORK MORE, SLEEP LESS

The advertising industry asserts that advertising merely redistributes consumption—from one product to another, a perpetual war between brands. Critics of advertising argue the opposite is true: that advertising increases overall consumption by creating needs. Advertisers state they're looking for market-share; critics claim they're expanding or creating markets.

The most famous advocate of the idea that advertising increases consumption is J.K. Galbraith in *The Affluent Society*. He argued that there was a "dependence effect"—that once basic human needs had been met, more must be manufactured to sustain demand in a growth-economy.[20] His assertion has recently been proven by researchers Benedetto Molinari and Francesco Turino in their study on the macroeconomic impacts of advertising: "We tested the spread-it-around [or 'market share'] against market enhancing [or 'dependence effect'] hypotheses as originally stated by Galbraith. Our main finding is that the second hypothesis is preferred by the data."[21]

Although human needs may be finite, human desire can be infinite.[22] The stoking of this desire has seen citizens take on an unprecedented level of consumer debt;[23] to service both our manufactured desires and the debt we take on in a never-ending attempt to quench their thirst, we're working more and more.[24] Research suggests there is a direct link between exposure to advertising and increased working hours. Academics at the British universities of Warwick and Nottingham found that while

working hours decreased between 1850 and 1950, working hours plateaued at around 42–43 hours per week in the following 40 years. Over the same period, advertising expenditure increased from £3.8bn in 1970 to 10.5bn in 1997. They used statistical modeling to explore the relationship between advertising spend and hours worked and found that:

[*"an increase in advertising is associated with an increase in hours worked... causality runs unidirectionally from advertising to hours."*]

HAPPINESS

[*"Advertising is not about catering to existing needs, but creating new desires. Not only desires, but insecurities as well, because we cannot desire without feeling we lack something."*[25]]

Advertising may be exceptionally adept at creating needs, but it is singularly bad at meeting them, at making good on its promises. Critics claim that unsatisfied needs are a cause of unhappiness. Furthermore, they posit a new form of cyclical consumerism that follows the "I eat because I'm unhappy" model: the more anxious and depressed we are, the more we must consume; the more we consume, the more anxious and depressed we become. Left-leaning think-tank Compass puts it this way:

[*"Advertising is the fuel that is driving this system; it persuades us to buy material possessions in the quest for happiness—but this is only making us unhappy... The goal of advertising then is not the creation of happiness and consumer fulfillment. Instead the purpose and consequence seems to be the creation of a mood of restless dissatisfaction with what we have got and who we are so that we go out and buy more."*[26]]

PEOPLE SCATTERED
LIKE RAIN
ACROSS THE LAND
SCAPE OF AMERICA
ARE SO SEPARATE
FROM EACH OTHER
AND LOST, THEY WILL
TURN TO ANYTHING
THEY CAN RECOG-
NISE FOR SOLACE,
LIKE FAST FOOD
DRIVE-INS WITH
THEIR SIGNS LIT UP
SO PRETTY IN THE
NIGHT OR MOVIE
STARS OR WAR

3

SOCIETY'S STORY

"It follows, too, that the masses [...] in the city are subject to manipulation by symbols and stereotypes managed by individuals working from afar or operating invisibly behind the scenes through their control of the instruments of communication."[27]

Louis Wirth

Advertisers like to profess that advertising only reflects existing cultural values, that their ads merely hold a mirror up to the world—any horror we might see was already there anyway. While this is undoubtedly true in one sense, subvertisers argue it's the emphasis advertisers place on certain of these innate values over others that's harmful. Again, the advertisers' assertion to the public that they have no real influence appears to be at odds with the claims they make to their clients.

CULTURAL NARRATIVE

Our cultural narrative is told in many ways and through many media undoubtedly it is the sum of all of these parts that tells our collective story. One of our most important spaces for telling that story—public space—is increasingly becoming privately owned and dominated by private interests. Jordan Seiler points out that the stories that are told by those interests are rarely, if ever, some "of our more interesting goals for ourselves as a

society, like community, taking care of our children correctly and education."[28] Bill Posters of Brandalism concurs with Seiler's sentiments regarding the dominance over our collective narrative held by private interests:

> *"We have always seen culture as the spaces and places where society tells stories about itself. Every society has a space where these stories are told and in our culture it's advertising that dominates these spaces (both physical and digital). If we want to understand the messages that define (popular) culture then we have to look at the main storytellers. In our culture that is the storytellers that have the most money—the advertisers."[29]*

Society both defines that story and is defined by it. The active shaping of our cultural values, and the dominance over that shaping by advertising, is an important part of subvertisers' objection to it. In a blog post that Jordan Seiler describes as a manifesto, he outlines why he thinks it's important to interrupt that dominance:

> *"I think it's important to question the monopolization of our public visual environment for commercial concerns and what that means for the determination of our collective social agenda. By privileging one type of message over another, we are, through repetition, setting the terms of our cultural and political discourse. Considering the great hurdles we face socially and environmentally, the commercial discourse we surround ourselves with not only ignores our current reality but actively works against it by distracting us from each other in favor of ourselves."[30]*

INTRINSIC VS EXTRINSIC

> *"Outdoor ads have become part of people's day-to-day urban wallpaper… and connect everyday ways of thinking to commercial imperatives."[31]*
>
> Anne Cronin

Subvertisers are not wrong to say that surrounding ourselves by commercial discourses has an important impact on both our values and our behaviour.[32]

Sociologist Joseph Schwartz identified a number of values that occur consistently across different countries and cultures;[33] these shared values can be split into intrinsic and extrinsic categories (see diagrams overleaf). It's important to note that everyone, everywhere holds all of these values to differing degrees; it's not that the values themselves are necessarily good or bad, simply that they have an influence on our behaviour.

Studies have shown that placing greater emphasis on extrinsic values is associated with higher levels of prejudice, less concern about the environment and weak concern about human rights.[34] The values displayed in advertising reflect the values of those creating advertising: the economic elite. It is perhaps not surprising that most advertising is designed to appeal to extrinsic values.[35] As subvertisers point out, that should be of concern to anyone who wants to promote anything other than individualistic consumption, because our values influence our behaviours.

A further cause for concern is that these values work in opposition: if a person has strongly held extrinsic values, this will diminish their regard for intrinsic values and vice-versa.[36] Not only

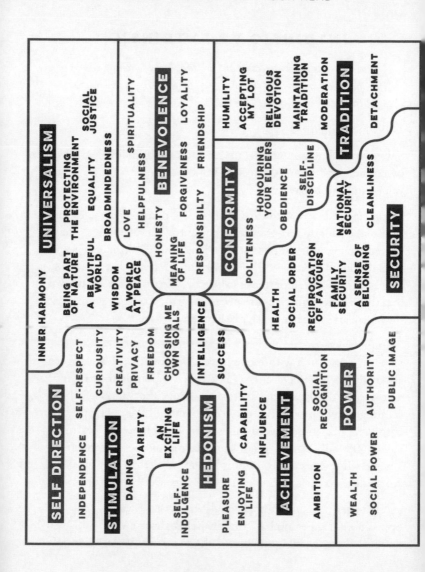

INTRINSIC VALUES

AFFILIATION
To have satisfying relationships with family and friends.

SELF-ACCEPTANCE
To feel competent and autonomous.

COMMUNITY FEELING
To improve the world through activism or socially creative projects.

BENEVOLENCE
Preserving and enhancing the welfare of those with whom one is in frequent personal contact (the 'in-group').

UNIVERSALISM
Understanding, appreciation, tolerance and protection for the welfare of all people and for nature.

EXTRINSIC VALUES

CONFORMITY
To 'fit-in' with other people.

IMAGE
To look attractive to other people in terms of body and clothing.

FINANCIAL SUCCESS
To be wealthy and materially successful relative to others.

ACHIEVEMENT
Personal success through demonstrating competence according to social standards.

POWER
Social status and prestige, control or dominance over other people and resources.

do advertisements place an emphasis on extrinsic values, but by repeatedly emphasising those values, it serves to strengthen them. Again, we don't even need to be persuaded to buy the product: simply by seeing messages with extrinsic values emphasised, we can subconsciously buy into those values.[37]

Advertisers place the emphasis on extrinsic values—subvertisers want to pull the balance back towards the intrinsic.

Curfew

C

Mon - Sun
6 pm - 7 am

Social Cleansing

JCDecaux

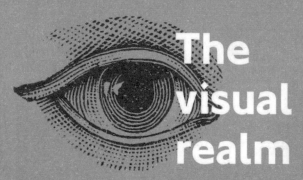

The visual realm

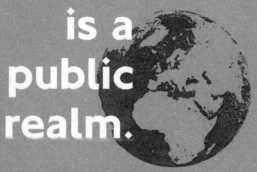

is a public realm.

It belongs to everyone, so no-one should be able to own it.

#AdvertisingShitsInYourHead

SUBVERTISERS
FOR LONDON
PUBLIC SPACE MATTERS

4

RIGHTS TO THE CITY

"Under these conditions, ideals of urban identity, citizenship and belonging—already threatened by the spreading malaise of a neoliberal ethic—become much harder to sustain."[38]

David Harvey

WHO OWNS WHAT WE SEE?

The founder of the modern public relations industry, Edward Bernays, is by no means the only person to recognise that "the tendency of big business is to get bigger."[39] It is certainly true in the outdoor advertising industry, where a handful of companies now dominate the landscape. And it is true both in terms of the companies that own those spaces, and the companies that can afford to occupy them.[40]

One member of the Special Patrol Group (SPG) tells a story about one of the first times they went out to do ad takeovers on the London Underground. As they were slotting a subvert over the original ad in an ad space, a commuter interjected and blustered at them: "You want arresting! Why don't you just pay for your advertising, like everyone else?" It serves to neatly illustrate both the perceived sanctity of the private nature of these public spaces—that anyone interfering with them should be arrested—and also the misconception that

these spaces are somehow open to all.[41] The reason the SPG were subvertising is because not everyone can afford to access those spaces.

A commonly stated motivation for the modern subvertising movement is the ubiquity of outdoor advertising and the monopoly held over public space by private interests.[42] The industry itself uses its ubiquity to sell outdoor advertising: the internet has broken the monopoly on people's attention that television previously held, but the urban landscape is still a space through which everyone must inevitably traverse.

Subvertisers want to reclaim that space for all.

PRIVATE PUBLIC SPACE

An important part of how this dominance has been achieved is through the private ownership of public provision—particularly public transport provision.[43] Advertisers have literally written their names on things that are supposed to belong to everyone. Capitol Outdoor boasts on its website: "Outdoor advertising [...] incorporates your targeted branding message into the everyday landscape of commuters and becomes part of the very fabric of the living and working environment where it is placed."[44] Clear Channel Outdoor, too, are open about their motives: "When brands advertise on our street structures, they become part of the public social space, entering people's thoughts and conversations."[45]

The private ownership of public infrastructure is a worrying tendency, because it inevitably leads to provision based on potential for profit rather than public utility (or other non-

economic notions); this, in turn, further cements the idea that only the profitable is imaginable on our city streets. The inverse corollary of this trend is the provision of useless street-furniture, the sole function of which is as a site of advertising. Jordan Seiler describes the pointless proliferation of public phone boxes in New York City:

> *"I think we have about 20,000 of them, which means 60,000 ads changing every month. They are simple to get into and it's just a ubiquitous form in NYC that people don't even use for their phone calls. They are just advertising venues at this point, because everybody has a cell phone."*[46]

One of the reasons private provision of public infrastructure may be tolerated is that we imagine the cost is shouldered by the beneficent provider, which represents a saving to the public purse. But advertising spend has the effect of increasing the cost of the product advertised, and that cost is ultimately passed on to the consumer.

There is no such thing as a free bench.[47]

RIGHTS TO THE CITY

> *"The right to the city is far more than the individual liberty to access urban resources: it is a right to change ourselves by changing the city. It is, moreover, a common rather than an individual right since this transformation inevitably depends upon the exercise of a collective power to reshape the processes of urbanization. The freedom to make and remake our cities and ourselves is, I want to argue, one of the most precious yet most neglected of our human rights."*[48]
>
> David Harvey

The right to the city is a concept of French philosopher and sociologist Henri Lefebvre that was later expanded by Marxist geographer David Harvey. It can be roughly described as the right to make and remake the spaces in which we live, and it stands in opposition to corporate or state control of our environment.[49] The right to the city means the democratisation of *all* aspects of our lives within the urban sphere—labour, education, planning, etc. Subvertisers start from the aesthetic as a symbolic demand for complete control:

> *"We asked ourselves the question: what can we as a global network of citizens do to challenge the cultural pessimism arising from the power of consumerism? How can we facilitate the reclamation of our right to the city and the revolution of everyday life?"*[50]

Almost all practitioners talk about reclaiming public space.[51] "Public space" is a contested term, and it's questionable whether there has ever been a truly public space to which we can return; however, it may be possible to *create* a public space, and subvertisers

have been vocal about what that might look like. One possible vision of public space is described by Bill Posters:

> *"Public space is an arena in which no single authority should reign and multiple voices should be heard, so we started from a profoundly democratic conviction that the public sphere is a place for communication, a place where people can speak, establish their presence, and assert their rights."*[52]

Many subvertisers started out as individual artists in the street-art tradition, before realising that this too entails a question over inclusivity.[53] For this reason, an almost ubiquitous part of the modern subvertising movement is an attempt to spread the practice, in order to break the artists' as well as the advertisers' monopoly on form:

> *"We are working together to position the citizen as narrator, and in the telling reveal to others how the city can become a playground, stage and instrument for unsanctioned artworks and activist interventions."*[54]

STRATEGIES
FOR RESISTANCE

Outdoor advertising can and should be banned

Sao Paulo did it in 2007, and Grenoble followed suit in 2015.

#AdvertisingShitsInYourHead

5

BANI-SHIT

One strategy to remove outdoor advertising from cities that has had some success is the localised, government-enacted ban. For this reason, the final point of Special Patrol Group's Ad Hack Manifesto makes the claim that outdoor advertising both can and should be banned.

Outdoor advertising bans certainly *can* happen, and there are a few precedents for them. In 2007, São Paulo enacted the Clean City Law, which designated outdoor adverts a form of visual pollution. As a consequence, 15,000 billboards and over 300,000 oversized storefront signs were removed in under a year.[55] In 2015, Grenoble, France, became the first city in Europe to ban outdoor advertising; 326 advertising spaces were replaced with community noticeboards and trees. The mayor's office stated it was "taking the choice of freeing public space in Grenoble from advertising to develop areas for public expression"[56] (perhaps an explicit reference to a right to the city?).

To date, these have been the only citywide outdoor advertising bans, though there have been other attempts to trim back the proliferation of outdoor advertising: in 2009, Chennai, India, banned the erection of new billboards, and there are also several US states where billboards are banned.[57] Paris planned to reduce the number of advertising hoardings by a third in 2011 and, in 2015, Tehran replaced all of its 1,500 commercial billboards with art for ten days[58] (more than doubling Brandalism's largest citizen takeover to date—600 bus stop ad spaces in Paris in November

2015). Local campaigns in Bristol (UK) and Berlin are working with communities and making appeals to legislators to become the next cities to introduce blanket outdoor advertising bans.

At first glance it may appear that advertising bans are a positive step, but academic Kurt Iveson questions the rationale for them. Though some activists may see their work as anti-authoritarian, he claims the cities that have introduced bans may be doing so in order to reassert the dominance of the state. He suggests a ceremonial normative model of public space, which privileges civic order above private commercial interests, but also views the public as a passive audience for "ceremonial, monumental and architectural displays, which might exercise a civilising influence." State-led advertising bans are concerned with "the aesthetic integrity of the public realm... rather than its democratic accessibility."[59]

Some subvertisers, too, are wary of government-enacted bans. Rather than a citywide ban on advertising, Jordan Seiler would prefer spaces to be available for all citizens to use: "This should be self-organised, you should just allow public messaging and scrawl on the streets. That's probably utopian, but I think a more viable solution would be to create places and structures that would support an open curation of some sort."[60] He also questions the motives behind the bans,[61] and points out the ban in São Paulo has only been partial: at the same time as the Clean City Law was introduced, the city signed a contract with JCDecaux to provide advertising-funded bus shelters. By eliminating the haphazard clutter of billboard advertising, it's entirely possible that the Clean City Law will benefit the companies that hold a monopoly on advertising infrastructure,

which is slowly being reintroduced in a "controlled manner." This effectively eliminates the competition and means that a few big companies are once again allowed to dominate.

Almost all governments are wedded to the capitalist system of production, so it's unlikely they'll decide to ban advertising in order to quell consumption. For this reason, direct action remains a vital strategy against outdoor advertising.

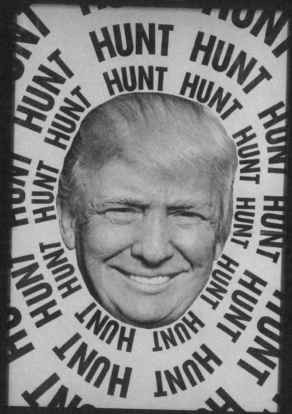

6

SUBVERTISING

"Subvertising," a portmanteau of "subversion" and "advertising," can be defined as any type of action that subverts advertising. This may range from improvised graffiti-style interventions, to the more coordinated campaigns of the modern era. Generally speaking, subvertising either targets the original adverts or the sites of outdoor advertising (or both).

Though it is difficult to say when exactly subvertising emerged as a form,[62] the history of organised outdoor advertising subversion dates back to at least the 1970s. In 1977, the Billboard Liberation Front (BLF)[63] was formed in San Francisco and began setting about making what they termed "improvements" to outdoor advertising, as well as encouraging others to do the same.[64] The Australian BUGA UP (Billboard-Utilising Graffitists Against Unhealthy Promotions) collective started taking direct action against tobacco advertising in 1979 (because, in their words, "someone had to do something about it!"[65]) and claim to be one of the first groups to use the term "subvertising."[66] Both of these organisations still have websites that reflect on their history and give advice to potential practitioners.

The motivations for subvertising have traditionally been wide-ranging—from objections over individual products to aesthetic concerns, direct action to simple mischief. Though the strategies of altering, removing, or reversing[67] outdoor advertising may remain largely the same, today's subvertisers are a more co-ordinated movement,[68] with a more connected vision:

"Today, the practice of subvertising is reaching novel heights. Collectives are starting to connect globally to form an ever-increasing force of resistance against the visual and mental implications of advertising. Initiatives such as Brandalism, Brigade Antipub and Plane Stupid are beginning to specifically address the connections between advertising, fossil fuels and climate change. Intervening into advertising spaces that usually celebrate consumption, they divert messages towards ones of anti-consumption."[69]

DETOURNEMENT THIS

"The method is the most interesting part of Brandalism, since it's specifically designed to confuse the viewer a little. This is why the posters are usually playful, typically mimicking established designs. They are, I think, motivated by 1960s French Situationism— people who believed the culture, the 'spectacle' of modern society needed to be attacked, and done in such a way that would wind up, rile, mimic, anger, confuse."[70]

Subvertising is a distinct form of culture jamming—an attempt to "intervene in the visual landscape that shapes how we think.[71] It has a direct link to the work of the Situationist International (SI)[72]; in particular, subvertising can be thought of as a form of "detournement"—a rerouting or hijacking of capitalist messaging—a tactic that was pioneered by the SI.[73] This is true in terms of the aesthetic subversion of brands and their adverts, but also in terms of the physical hijacking of advertising spaces, or "takeovers."

One way that subvertisers claim this form of detournement may work is by intervening in the visual landscape to puncture

the "existing regime of truth."[74] As described earlier, outdoor advertising occupies an elevated position; by both intervening in the physical space containing the advert and altering the messaging,[75] subvertisers hope to displace "an already-established disposition"—to disrupt our habitual ways of thinking.[76]

AGAINST LIBERAL PRANKSTERS

A criticism of subvertising is that overemphasising its potential effect may be naïve. As academic Richard Gilman-Opalsky points out:

> *"Debord was well aware, in the 1950s and 60s, that something like sporadic 'subvertising' could never jam a culture of constant accumulation. Subvertising at its best is like a skip on a record that the needle passes over with a minor interruption."[77]*

It's possible that subverts may just be ignored or subsumed into habitual ways of thinking; it's also true that just as advertising works in a cumulative way, subvertising is most likely to be effective as part of a sustained campaign, rather than individual takeovers.[78]

Neither can subvertising call for reform if it is to be considered detournement, in the Debordian sense. Protest art academic Catherine Flood claims that Adbusters "shifted the focus of graphic resistance from creating radical alternatives to mainstream design and advertising to exposing and attempting to reform its practices."[79] The modern subvertising movement seems to have returned to the original Debordian critique of the spectacle, a critique that is suspicious of reform:[80]

> *"One must not introduce reformist illusions about the spectacle, as if it could be eventually improved from within, ameliorated by its own specialists under the supposed control of a better-informed public opinion."*[81]

In addition, where Adbusters took aim at individual brands and campaigns, even if this could be seen as part of a more systemic critique, it fired from a relatively elevated position. It did not attempt to pass the weapons around or bring in new recruits—those who aren't able to take part in the fight are necessarily relegated to the position of spectator.[82]

The modern subvertising movement attempts to mobilise these previously passive spectators and place them at the heart of the fight.

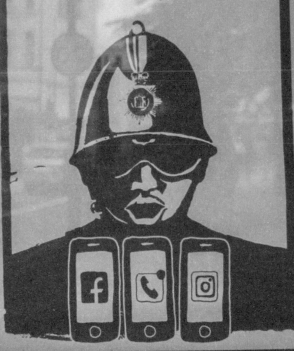

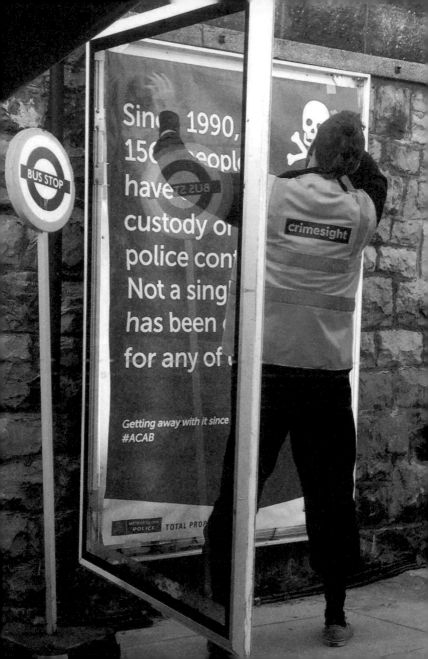

YEAH, WE GOT KEYS FOR THAT

One of the things that sets modern subvertising movement apart is the energy with which its various practitioners attempt to spread the form. Unlike other art-forms, there is little to be gained by retaining a monopoly on practice, and lots to be won by passing it around. Both Jordan Seiler and Bill Posters of Brandalism started out as individual artists, putting up their work in the street-art tradition; both came to the realisation that, for their work to make a genuine claim to the rights of the city, it must be a practice that is open to all.

There can be a few obstacles to subvertising, including accessing the spaces, printing materials, and installing your artwork. Thanks to the global monopoly on outdoor advertising spaces held by relatively few companies, many of these obstacles can be overcome on a global scale.

PRINTING

All outdoor advertising spaces worldwide are standardised sizes, so as long as you can find someone with a big enough printer, you get artwork printed in the correct sizes. At the time of writing, 6-sheets can be printed for about $15 and 12 printed 4-sheets for a 48-sheet billboard come in at around $80. Prices vary depending on location but, by comparison, if you were to pay for a billboard via an outdoor advertising company, it would cost you around $600 a week, with a $2,400 minimum spend.

ACCESS

It is perhaps a measure of the perceived sanctity of the spaces adverts occupy that the majority of them are either completely unprotected or only secured by standard locks, the keys for which can be easily found and purchased on the internet.

Both Brandalism and Special Patrol Group have put advice online about what access keys are required and where to find them. Special Patrol Group created an Ad Space Hack Pack that contains the three tools they claim can access "up to a third of outdoor advertising spaces in the UK."[83] Art in Ad Places have page on their website that informs people how to take over NYC phone booth ad spaces and where to find tools.

Public Ad Campaign have been making what they call "Public Access" keys available since 2014.[84] Each of them is handmade by artist-founder Jordan Seiler, who says:

> *"The idea after NYSAT [New York Street Advertising Takeover] was, ok, I can't do enough damage on my own. I need to figure out projects and ways in which other people can do the work, because I just don't have enough time or resources to do enough damage. And so Public Access really was about that."*[85]

Currently there are 11 different sets available, and over 400 have been sold worldwide. All of the international key-lock combinations are displayed on the Public Access site and if followers spot a lock that cannot be opened by any of the Public Access keys currently available, they can send a picture of it to Jordan, who will attempt to create a key for it. Jordan uses the hashtag #YeahWeGotKeysForThat to collect images of

How to hack into bus stop advertising spaces

What you will need

Hi Viz Vest

TX30

H60 Security Pin

4-Way utility key

Your artwork
1,200mm x 1,800mm

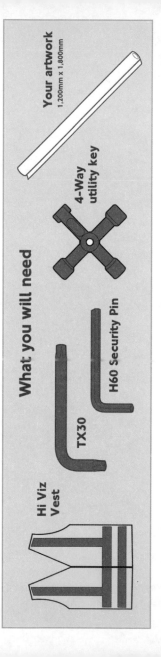

1 Choose a suitable bus stop location. The main bus stop advert company is JCDecaux, and there are hundreds of sites to choose from.

2 Select the 4-way utility key from the kit and locate the attachment that has a large square key shape. This will open the lock on the side of the advertisement shell.

3 Insert the square key into the lock and turn clockwise 180 degrees. Don't worry if it doesn't open first time, the mechanism can be stiff. Keep calm and keep trying.

4 Once the side panel is open, insert one finger into the bottom of the casing and slide the metal cover up to reveal the next key hole.

5

Take the T40 hex key from the kit, and insert it into the small hole whilst keeping the metal cover held up.

6

Once the key is located in the lock, turn anti-clockwise through 90 degrees to release the catches that keep the perspex screen closed.

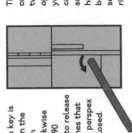

7

The perspex cover may have two pistions that open up when you release the catches. Make sure you keep hold of the bottom of the screen and let it rise slowly.

ℹ️ If installing at night time, turn the power breakers off inside the panel - just flick the switch down. You will feel Less exposed with the backlight.

8

Roll up the poster that is inside from the bottom.

9

Slide your poster into the top of the panel, push it into the clip the runs across the top of the perspex. You may wish to pre-fold a 1 cm edge on your posters, for an easier install. A credit card can also help with pushing the poster into the clip.

10

Put two hands on the bottom edge of the casing and push back to the frame to re-engage the catches, and close the door.

Then walk away; take your time; enjoy the experience.

 If the poster you are replacing has a blank reverse, you can re-use it for another installation: if not, you should recycle it.

#ADHACKMANIFESTO

subverting installs people around the world have done using his tools.

The spaces on the London Underground are completely unprotected and activists can just place a subvert over the top of the existing advert. In July 2016, Belgian activists from TTIP Game Over put up around 700 designs on the Brussels metro system in the same way.[86]

TRAINING

The first Brandalism campaign in 2012 was carried out by just two members, but the second campaign in 2014 saw those two members passing on their knowledge to 60 activists from 10 different cities around the UK. Training activists in the art of bus stop installs was again carried out before their campaign in Paris in 2015.[87] Brandalism has also created an online guide to installs.[88]

Members of Special Patrol Group were at Banksy's Dismaland and gave daily demonstrations on how to access ad space cabinets with an ad-cabinet installed especially on site. As part of their 2015 Total Propaganda campaign, they created a training video, which showed the tools to use and how the posters were installed.[89] The group also purchased a second-hand 6-sheet advertising display cabinet from Clear Channel, which has been installed on a long-loan basis to an arts and activist space in London and is used for training workshops that are open to the public.

Public Ad Campaign have put on a free training sessions in New York that introduced people to the history and theory of subverting as well as giving them the practical skills to do their own work:

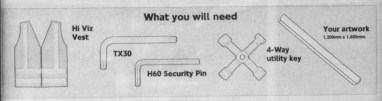

JCDecaux

How to hack this bus stop advertising space

What you will need

Hi Viz Vest

TX30

H60 Security Pin

4-Way utility key

Your artwork
1,200mm x 1,800mm

1
Choose a suitable bus stop location. The main bus stop advert company is JCDecaux, and there are hundreds of sites to choose from.

2
Select the 4-way utility key from the kit and locate the attachment that has a large square key shape. This will open the lock on the side of the advertisement shell.

3
Insert the square key into the lock and turn clockwise 180 degrees. Don't worry if it doesn't open first time, the mechanism can be stiff. Keep calm and keep trying.

4
Once the side panel is open, insert one finger into the bottom of the casing and slide the metal cover up to reveal the next key hole.

5
Take the T40 hex key from the kit and insert it into the small hole whilst keeping the metal cover held up.

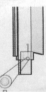

(i)
If installing at night time, turn the power breakers off inside the panel - just flick the switch down. You will feel less exposed with the backlight.

6
Once the key is located in the lock, turn anti-clockwise through 90 degrees to release the catches that keep the perspex screen closed.

7
The perspex cover may have two pistions that open up when you release the catches. Make sure you keep hold of the bottom of the screen and let it rise slowly.

8
Roll up the poster that is inside from the bottom.

9
Slide your poster into the top of the panel, push it into the clip that runs across the top of the perspex. You may wish to pre-fold a 1cm edge on your posters, for an easier install. A credit card can also help with pushing the poster into the clip.

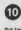

10
Put two hands on the bottom edge of the casing and push back to the frame to re-engage the catches, and close the door.

Then walk away; take your time; enjoy the experience.

If the poster you are replacing has a blank reverse, you can re-use it for another installation. If not, you should recycle it.

#ADHACK MANIFESTO

SUBVERTISERS FOR LONDON

> *"This event starts by offering a brief historical and theoretical overview of the practice before sharing all the practical skills and knowledge required for undertaking your own advertising takeovers in New York. We'll bring in posters and painting materials to create our own adverts during the workshop. Come and join us!"*[90]

Jordan's previous campaigns have also aimed to be inclusive: his ad takeover projects involve up to 100 people hitting the streets and reclaiming ad spaces together, and anyone could get involved in the open call-outs.

AN IDIOT'S GUIDE
TO BILLBOARD TAKEOVERS
BY DR D

A. Lingo

Know your terminology, amaze your friends. A billboard is also known as a 48-sheet as it is made up of 12 (60" x 40") sections. Each of the 12 sections is called a 4-sheet as they are 4 x double crowns (30" x 20") in size.

B. What's the point?

What is your billboard take over going to be, have you got a point or are you being decorative? Either way, show your idea to a friend. A typo on paper is one thing; a typo on a billboard just makes you look like a big wanker that can't spell. It's the difference between knowing your shit and knowing you're shit (I stole that line).

If you're printing your masterpiece, go to C. If it's cutting one up, go to D. People who paint, go to E.

C. Size matters

The print size for a standard billboard is landscape 10ft x 20ft or 3m x 6m. If you get one printed online, you really want it printed on blue back paper. This paper requires pre-soaking in water before sticking and keeping it moist in a plastic bag is essential. The pre-soaking of blue back means it's easy to move and line up on the board and it dries perfectly flat and professional-looking. Make sure you number each of the 12 sections on the top at the back and roll from the bottom up. Work from the top left and have your ladder in the middle of the first two posters. That way you should be able to reach all the posters, only moving your ladder to three positions.

Don't try and pre-soak any other paper, you'll just end up with papier-mâché. If you know your printer, happy days; if not, be aware they can be like the Stasi—they have a code of conduct that means if they think what you're asking them to print is likely to cause offense, they won't print it and obviously they now know what you're up to. I did have a printer once refuse to print an image of David Cameron's face, so the lines on what can be considered offensive are subjective.

D. Cut up jobs

If you have two billboard images you want to mash up together, you can cut a section from one with a knife and peel off. Once away from the scene you can tease the paper you don't need from the back of the piece until it's thin enough to re-stick with paste onto another board. As it'll have the industry-standard blue back paper it usually dries perfectly, hiding the fact you've added a bit. I did this with the first board I ever altered, moving

"SU" from one board and sticking it onto another so "CLICKS" became "SUCKS," the whole phrase becoming "SUDDENLY EVERYTHING SUCKS."

E. Paint jobs

Do you need me to tell you to use something that won't run in the rain? Aerosol or acrylic or even exterior masonry paint will do you...

F. Getting on board

You'll be safest on a two-section ladder that you can put up to the top and rest the ladder brackets on the billboard for your comfort and reassurance. Remember: vandals don't bounce, so don't over-stretch. Use a bucket for your paste hung from the ladder with an S hook; you'll need your hands for positioning your poster. You can get a bill poster's brush online; you could also use a soft-bristle broom, but if I see you I'll really mark you down on style for that. A fat wallpaper brush is just about usable, but you're going to be up that ladder three times longer than you need to be—if you're only changing a bit of lettering or imagery it would work fine.

G. Timing is everything

Generally speaking, boards in busy cities are changed every two weeks. Out of town that might become every month. If you watch when they change you can figure out the best time to carry out your takeover. If you've been covered over and you find the board still wet you can peel off the poster you've been covered by. Do keep in mind the bill poster will now really want to kick your arse.

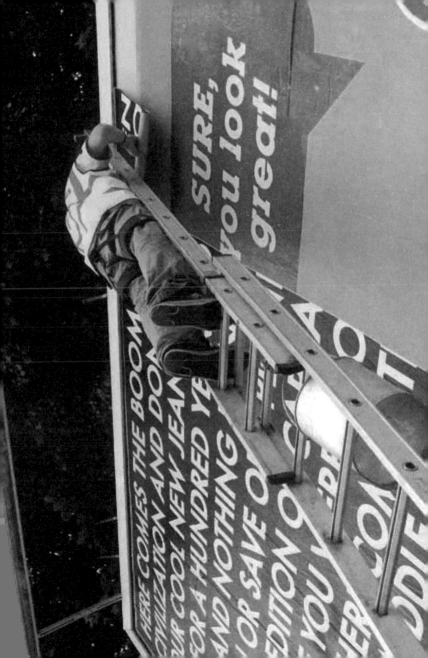

H. Caution!

Some boards have nothing on them as they've become dangerous. Quite often the wooden platforms become rotten and never get removed.

I. Legal bizzle

Technically speaking you're putting a poster on a site that is designed to have a poster on it so legally you're not flyposting or criminally damaging it. If you cover every board in town week after week then someone will probably try and shut you down as you're losing them money. A one-off takeover they'll just cover you up, no problemo.

J. Sticking it to the man

A bucket of hardware store wallpaper paste or some wheat paste will work fine.

K. Hide in plain sight

Orange is very much in vogue on the Outdoor Advertising scene— hi-viz jacket and trousers as standard. Why not accessorise with a hardhat, too? I have no idea why they make them wear these, I have thus far never been injured by falling paper. Going by the book, you should wear a harness that attaches you to the ladder.

L. Skin jobs

Not just the enemy in *Blade Runner*. Check that the board you want to paste on to isn't a "skin." They are a type of plastic, various types are in use, and you can't paste on to these boards, but you can use some spray mount or carpet adhesive spray.

A GUIDE TO HACKING
NEW YORK PHONE BOOTHS
BY ART IN AD PLACES

Some essential info

Ads in NYC pay phones come in three sizes (all noted in inches). Portrait-oriented (the vast majority of ads spaces, sometimes facing so that they are visible from across the street but usually facing so that they are visible as you walking along the sidewalk directly towards a pay phone):

1. 26" x 50"

Landscape-oriented (less common, always facing so that they are visible from across the street):

2. 46" x 60"

3. 38" x 78"

On most NYC pay phones that have ads, the ad spaces open on a hinge, essentially window frames. That's the style of ad spaces that this guide focuses on. A handful of ad spaces are more like large picture frames, but they are difficult to disassemble and install in, not worth the energy. Ignore those ad spaces and move on to the ones on hinges.

The ad spaces are not so much locked as they are closed with atypical screws. This is "security through obscurity," and lucky for you, the solution is easy: Buy the right tools. All told, they might cost $30–40. You'll need:

1. One multi-bit screwdriver, any screwdriver with interchangeable bits should do.

Phone

PURCHASE
HE PROPER
BOOTS
WITH WHICH

THE
RAPS

2. A set of "security bits" for your screwdriver. These won't come standard with the screwdriver, but the standard security bits set at any hardware store should do. What you're really looking for in that set are the hex bits. They look the same as regular hex keys or bits, except with a little hole in the center. Those hex bits will match up with the hex security screws used on many pay phone ad spaces.

3. A tri-groove bit, specifically a bit for sizes number 8 to number 12. These are a bit more difficult to find, but search engines can help. This bit should also fit onto your multi-bit screwdriver. Or, if you find it's easier to find a tri-groove socket, you'll also need a socket wrench.

How to

1. The screws locking the ad spaces are generally located on the metal frame of the window so that they're visible as you're looking directly at the ad. Occasionally they'll be located elsewhere along the frame.

2. Identify the screw type, and select the appropriate bit.

3. Remove the screw or screws on the frame, and it should freely swing open like a door. If the frame isn't budging once the screws are out, try using a flat bottle opener like a crowbar along the frame to pry it open.

4. Remove the ad. The ad will be printed on a heavy plastic-like material. It will roll up, but it won't stay rolled up unless you put it in a tube.

5. Depending on how well-maintained the pay phone is, the specifics of what's inside might be different. You're looking

to sandwich your poster between two layers of plexiglass: The plexiglass (sometimes real glass) of the frame, and the layer of plexiglass inside of the window, window, which is revealed once the frame has swung open and the ad is removed. Some booths are missing this inner piece of plexi. On others, it stays in place when the frame is opened, and on others it is attached to the swinging frame with metal notches along the top and bottom of the frame.

6. In an ideal scenario, you'll be able to tape the top of your poster to the inner piece of plexiglass, unroll it, tape it the bottom of the poster to the inner piece of plexiglass (optional). Depending on the state of the pay phone, you may have to improvise exactly where the tape goes.

7. In the case of ad spaces where the inner plexiglass is attached to the frame with those notches, the process is slightly different and annoying. Pull the inner plexiglass so that unlatches from the top notches and can feely fall back as if its bottom edge is on a hinge. Sandwich your poster between the two layers of plexiglass and push the inner layer back into place so that it locks with the top notches. Taping the poster to the plexi may or may not be necessary in this case.

8. With your poster in place, close the frame.

9. Re-insert the screw(s) in the same holes you removed them from.

10. In a pinch, if the screws no longer engage with the frame (these things are in terrible shape, and can fall apart just by being opened), be prepared to tape the frame shut with some strong tape.

11. Walk away.

Removing,

~~a~~ **replacing,** ~~g~~

and ~~defacing~~ advertising is

not vandalism.

It is an act of tidying up
that is both legally and
morally defensible.

#AdvertisingShitsInYourHead

SUBVERTISERS
FOR LONDON
PUBLIC SPACE MATTERS

8

LEGAL DEFENCE

> *"Any advert in a public space that gives you no choice whether you see it or not is yours. It's yours to take, rearrange and re-use. You can do whatever you like with it. Asking for permission is like asking to keep a rock someone just threw at your head..."*
>
> *Banksy/Tejaratchi*[91]

Wherever it happens around the world, subvertising can potentially carry a criminal charge. For some subvertisers, the best strategy where the law's concerned is to avoid being caught in the act and to act anonymously. Brandalism and Special Patrol Group advise against arousing suspicion by wearing the "international cloak of invisibility known as hi-viz."[92] As an anonymous member of the SPG told the *New Statesman*:

> *"Nobody in our group has ever been caught because it is absurdly difficult to get caught doing something that is usually someone's job—even when you're putting up posters about deaths in custody, bearing the ACAB slogan, outside the HQ of the British Police Force (twice)."*[93]

Others are more open. Jordan Seiler of Public Ad Campaign views his work as civil disobedience and, as such, says it's important to be able to claim his actions. In the US the charge for subvertising is for possession of graffiti materials; Jordan has

himself been arrested doing ad takeovers, and nine volunteers were arrested taking part in his NYSAT project, spending a total of 310 hours in jail collectively.[94] Part of the tradition of civil disobedience is "acting as though you're already free,"[95] and it is in this spirit that Jordan considers the law:

> *"I don't think of what I do as illegal, I think it's a valid form of protest. It is technically illegal, but not all laws are just. There's a history of property disobedience and violence against property, because in a capitalist system we privilege property so heavily, it's taken seriously."*[96]

In France, subvertising group Robert Johnson[97] use the tactic of deliberately getting arrested for their actions in order to have a conversation about the harms caused by advertising in court. They use the defence of necessity, claiming that their actions are necessary, and therefore lawful, because they help to prevent a greater harm. Traditionally it has been dismissed by the judiciary, but on March 25, 2014, a French magistrate agreed that their actions were indeed lawful and acquitted the group of all charges.[98] For this reason, March 25 has been declared an international day of action against advertising by subvertising groups worldwide.

Further potential for legal action comes from the companies subvertising attacks, whether that's the brands that are subverted or the owners of outdoor advertising sites. In July 2016, 700 adverts on the Brussels metro system were replaced with subverts bearing protest messages (against TTIP—the Transatlantic Trade Investment Partnership); the group that claimed the action—TTIP Game Over—was subject to a joint police complaint by the

company that runs the metro system (STIB) and the owners of the advertising sites, JCDecaux;[99] however, the police decided no further action was necessary.

Taking legal action also has the potential to very publicly back-fire. A recent article in the *Oxford Journal of Intellectual Property* made it clear that, outside of subvertisers being caught in the act, there is minimal legal protection against subvertising. The authors point to a judicial trend towards affording greater protection to freedom of speech, as well as an expansion of what can be considered parody and fair use. Additionally, the potential for bad publicity stemming from prosecution could be too high:

> *"Brandalism may well be a huge annoyance to brand executives who see their corporate message hijacked. In-house counsel and external advisers may find themselves pressured to act in a fast and firm manner, given embarrassment and perhaps anger at executive or board level. There are certainly legal tools that can be evaluated; however, there are clear signs that the law is evolving towards greater protection of freedom of speech, which should give brands pause for thought. The general development in recent years towards elevating citizens' rights around social commentary and parody above the intellectual property rights that are subject to them puts brand owners in a difficult legal position. Beyond the legal strictures, there are likely enormous practical difficulties in securing a remedy and is, above all, a real risk that ill-conceived or knee-jerk responses will only make the situation worse."[100]*

The legality of subvertising seems, currently, to be something of a grey area; what's clear is that subvertisers see their actions as morally defensible, regardless of the legal position.

THE SUBVERTISERS

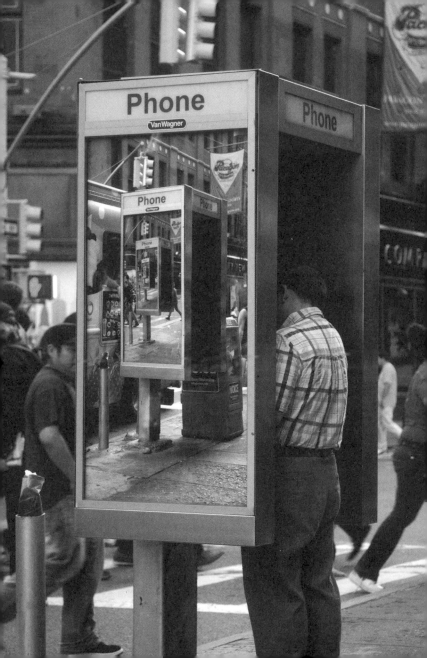

PUBLIC AD CAMPAIGN

Jordan Seiler began subvertising at the end of art school. After being challenged by a teacher that he probably wouldn't take over all of the ad spaces in a subway station for his thesis, that's exactly what he did. His practice grew from there, as he took on more and more ambitious takeovers—including the world's first international outdoor ad takeover. He sees himself as more of an artist than an activist and says he lacks traditional political ambition; however, he also says that he considers good art to be activist.[101]

Unlike some of the other subvertisers featured, Jordan prefers not to work anonymously, because he feels it's important that he claims ownership of his output. Starting out in the street-art tradition, he called the project Public Ad Campaign as a pseudonym, but has since been more open about his identity, as he says, "it's important to identify with your demands, to own them. Rosa Parks would not have been Rosa Parks as Anonymous."[102]

In addition to his collective projects below, Jordan still does independent installs in his native New York and all around the world.

PUBLIC ACCESS KEYS

Jordan had initially been working with public telephone spaces in New York that aren't secured, so didn't have any need of access tools. But when he visited Madrid for the MASAT project, he met Vermibus, who had replicated an original JCDecaux key. This

gave him the idea that it could be done, and later he figured out how to replicate them in his workshop at home.[103]

There are now 11 different keys available, and Jordan's sold around 400 sets of access keys so far. If someone spots a lock that doesn't currently have a key, they can send a photo to Jordan, who will try to replicate it for them and then make it available online.

Jordan says that PublicAccess Project

> *"aims to reverse this one-way communication by providing access to municipal infrastructure for public dialogues. Artists and individuals can treat the tools offered through this site as functional sculptures to interject their thoughts into our shared public spaces."[104]*

COLLISIONS SERIES

Jordan works with black-and-white geometric shapes, which—although aesthetically considered—deliberately avoid using a slick commercial advertising design aesthetic.[105] His black-and-white installs are as far removed from adverts as possible, without just looking like empty spaces (which they would be if they were just black or just white).

NYSAT

New York Street Advertising Takeover (NYSAT) was the first time Jordan decided to expand his personal subvertising practice to get more people involved. Targeting a company in New York City that exclusively used illegal advertising spaces meant that it was relatively easy to recruit, and Jordan credits "the hard work

and dedication of over 100 artists, activists, photographers, videographers, lawyers, mothers, fathers, students, teachers, and public citizens."[106]

The action took the form of citizens white-washing the illegal ad spaces; this removed the adverts and created a blank canvas, which many artists then filled with their work. It also garnered media attention, from outlets including the *New York Times*, *The Economist*, *Adbusters*, and *Juxtapoz*.

TOSAT

The Toronto Street Advertising Takeover (TOSAT) was the first international street ad takeover project.[107] Rather than simply painting over illegal fly-posting, this time the project was accessing legal spaces—Pattison Outdoor Core Media Pillars—and replacing them with posters: 60 artists were invited to submit artwork and over 90 media pillars had their adverts replaced, as well as 20 billboards. A team of local volunteers was recruited to perform the installs and information on how to access the spaces—using an ordinary household doorknob—was made available on the TOSAT mini-site. The action was featured in local Toronto news and internationally via street art sites *Juxtapoz* and *Vandalog*.

MASAT

Madrid Street Advertising Takeover (MASAT) was Jordan's second international ad takeover campaign, and happened on March 31, 2011. This time, instead of using artworks, contributors were asked to provide text-based submissions, which opened up the process to "a wide range of individuals including sociologists,

teachers, lawyers, gallery owners and anyone with a concern for the curation and participation in public space."[108] In total, 106 different text-based designs were submitted and installed.

PUBLIC HEALTH CAMPAIGN

In November 2017, Jordan travelled to Saint-Étienne, France, for Santé Publique, a public health art project in collaboration with local arts association Le MUR. Together they facilitated 75 residents of the City to create and install their own original artworks in advertising spaces. Respondents to the open call-out came from a wide range of demographics and professions, and no artistic talent was required.

Le Mur said the project was: "A great national and international premiere in terms of public expression. The word was thus offered to all those, artists or not, who wanted to express in graphic or artistic voices their idea of the city in the broad sense."

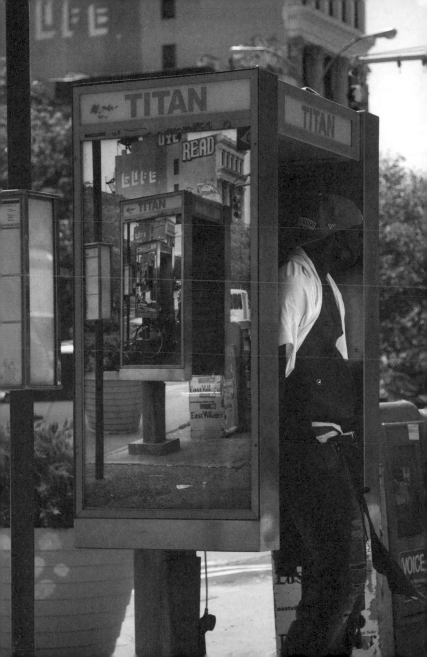

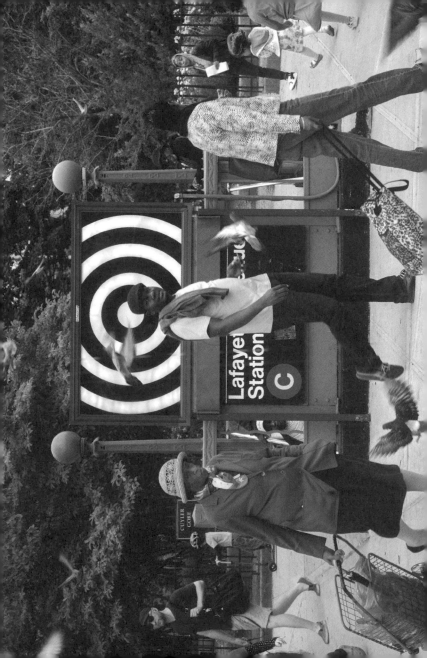

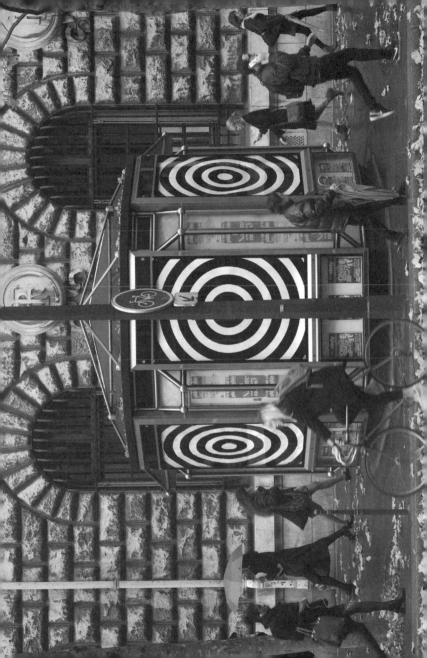

Strøk (Norway), Stavanger, 2012

Swoon (USA), Red Hook, 2013

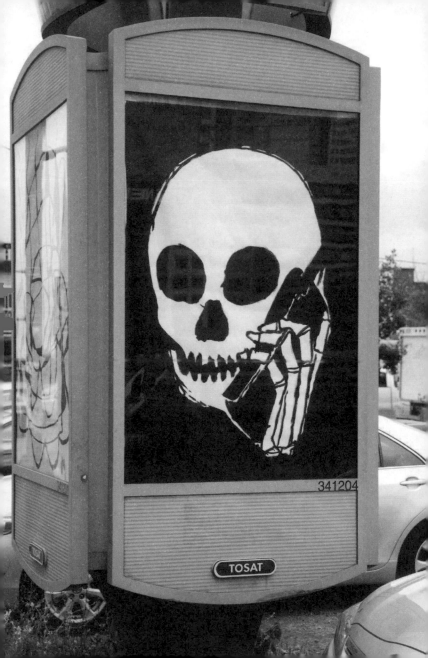

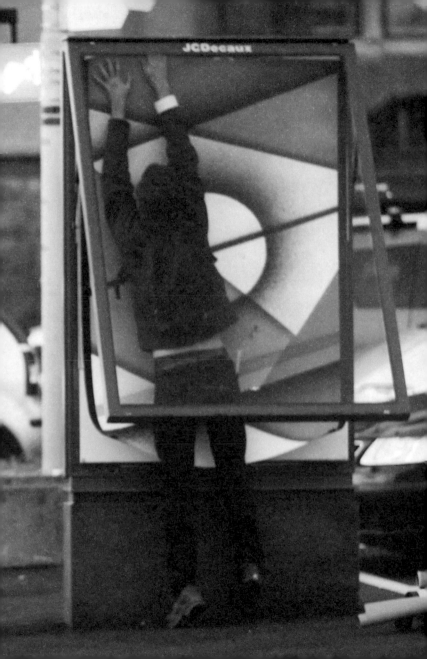

BRANDALISM

Bill Posters started his art life as a graffiti-writer, tagging roofs, trains and walls as part of a crew whilst at university. After becoming more politicised by the Iraq War, he ended up writing his dissertation on culture jamming, referencing Lefebvre, Klein and the Situationists, and says this acted as the "anti-business plan" for what became Brandalism.[109]

The first Brandalism project in 2012 had billboards and consumerism as its target, and saw Bill recruit a friend (who is still part of the anonymous Brandalism crew) to help with the installs. Though the billboards caught the attention of much mainstream media, the billboard twosome quickly realised that they were "just two blokes in a van."[110] Since then, their focus has been on empowering others to take their own actions, and every campaign since has seen more and more volunteers get involved.[111]

Bill Posters sees the work of Brandalism—replacing adverts with art—as a gift.[112] Unlike advertising, it demands nothing of the viewer and can be viewed as a two-way interaction. Internationally acclaimed artists have featured in the Brandalism projects—Peter Kennard, Gee Vaucher, Robert Montgomery—but on the street they're presented anonymously.

BRANDALISM 2012:
THE BILLBOARD

The first Brandalism project happened in July 2012, across five major cities. Two installers pasted up 36 large-format billboards (48-sheets) with original work from 28 international artists. The project was deliberately timed to coincide with the "protective brand-mania that characterised the London Olympics"[113] and as such gained international media attention, provoking "a discussion about the legitimacy of outdoor advertising spaces that we are forced to interact with."[114]

BRANDALISM 2014:
THE 6-SHEET

Concerned that there were questions over the democracy of the project, Brandalism prepared for round two with a three-day training course on both the theory and practice of subvertising. Ten crews from all over the UK attended and collectively helped to select and print the artworks that would be installed on the streets.

Over two days, 365 artworks were installed in bus-stop-sized advertising panels in Edinburgh, Glasgow, Liverpool, Manchester, Leeds, Birmingham, Brighton, Bristol, Oxford and London. The installs again included work from internationally acclaimed artists but were again anonymised.

BRANDALISM 2015:
PARIS COP21

The Paris project was in support of protests against the COP 21 conference and attempted to make the connection between

consumerism and environmental destruction explicit. In particular, the project took issue with what they saw as green-washing of the climate talks:

> *"Increasingly, these talks are dominated by corporate interests. This year's talks in Paris are being held at an airport and sponsored by an airline. Other major polluters include energy companies, car manufacturers and banks. Brandalism aims to creatively expose this corporate greenwashing."*[115]

The Brandalism crew were in Paris for two weeks leading up to the day of the action, where they printed off the 600 posters which would eventually be installed. During this time they also made tools for accessing Parisian bus stop cabinets and trained local teams in the art of installation. Despite Paris being under a state of emergency with all street protests banned, Brandalism pulled off their biggest takeover to date and garnered international mainstream attention for their efforts.

SWITCH SIDES

A day of international action against advertising had been called by French subvertising group RAP and, in response, Brandalism created their Switch Sides campaign. Posters were designed that specifically addressed the workers from top ad agencies Ogilvy Mather, ABDO, and WMT, and then installed outside their offices in Manchester and London. A link was printed on the posters that took users back to the Brandalism site and a short article explaining why they thought that people who work in the industry ought to switch sides:

"We installed those designs in Manchester and London to start a conversation with you. Congratulations on making it into one of the country's top advertising agencies. We were triggered by a particular concern: that your talent, energy and creativity is sinking into an ever-expanding black hole. Your creativity could mean so much more."[116]

We're sorry that we got caught.

Now that we've been caught,
we're trying to make you think
we care about the environment.
But we're not the only ones.
#redlines #D12 #ClimateGames

Das Auto.

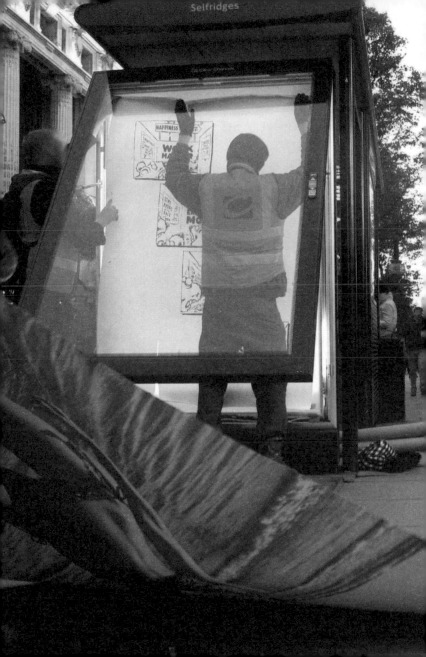

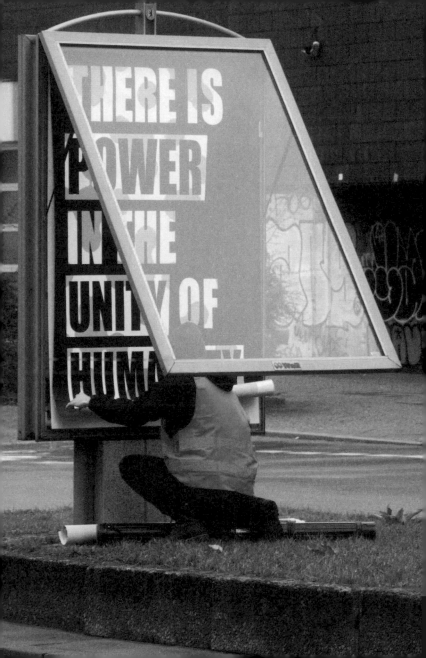

JCDecaux

TACKLING CLIMATE CHANGE?

OF COURSE NOT. WE'RE AN AIRLINE.

We're sponsoring the UN climate conference so we look like we're part of the solution and to make sure our profits aren't affected.

Economic growth is far more important than saving the planet. So we'll keep on bribing politicians and emitting greenhouse gases.

Just keep it to yourself.

AIRFRANCE
PART OF THE PROBLEM

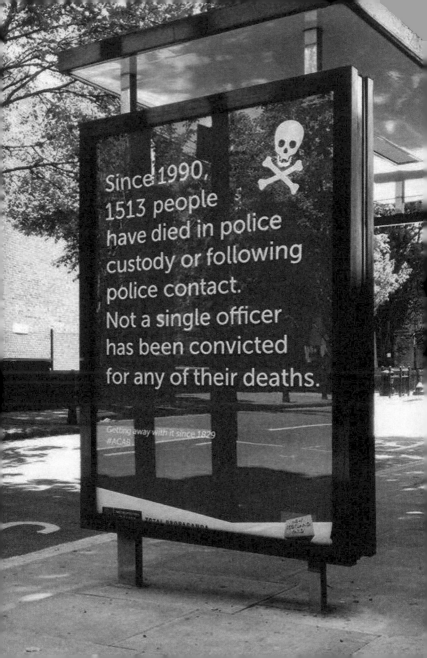

Since 1990, 1513 people have died in police custody or following police contact. Not a single officer has been convicted for any of their deaths.

Getting away with it since 1829
#ACAB

SPECIAL PATROL GROUP

Special Patrol Group (SPG) are a shadowy subvertising organisation based in London. They're thought to be named after the controversial, and now disbanded, Metropolitan Police Force unit notoriously responsible for the death of activist Blair Peach.

The SPG started subvertising by taking designs from *STRIKE! Magazine* and installing them in bus stop 6-sheet spaces, billboards and London Underground ad spaces. In 2015 they were invited to be part of Banksy's Dismaland exhibition, where they gave demonstrations in bus stop hacking, and first made their Ad Space Hack Pack available.

More recently they've been installing subverts on behalf of other campaigns and plastering London with their own anarchist-inspired art and counter-propaganda.

TOTAL PROPAGANDA

The first campaign by the Special Patrol Group was an action to counter what they claimed was the propaganda of the Metropolitan Police Force's "Confidence Campaign"—a hyper-localised poster marketing campaign targeted at "areas with low confidence in the police." In November 2014, three designs were installed in around 30 sites in London—including outside New Scotland Yard, headquarters of the British Police Force—mimicking the police's own posters, but with "more honest" messaging (the tagline, Total Propaganda, is a subversion of the Met's Total Policing slogan).

The designs highlighted institutional police racism, the unlawful killing of Mark Duggan, and discriminatory cannabis laws. The bus-stop installs went viral and were featured by several major news outlets.

The Met did another round of confidence campaign posters early in 2015, and the SPG again responded with their own campaign. This time they focussed on deaths in custody, police corruption, and the amount of public money the Met spent on their own pointless propaganda campaigns.[117]

Downloadable versions of all the designs were made available through *STRIKE! Magazine*'s website, to encourage people inspired by the campaign do their own subvertising.[118]

BULLSHIT JOBS

On the first day back to work for most in 2015, quotes from David Graeber's article "On the Phenomenon of Bullshit Jobs" that questioned the nature of work under capitalism were inserted over regular ads on the London Underground system.[119] Images of the installs spread quickly on the internet and received major news coverage. This is the start of a trend of linking their subvertising back to articles and anarchist theory.

DON'T VOTE!

Two weeks before the UK General Election, the Special Patrol Group—whose work is informed by anarchist theory—install designs questioning the voting system in bus stops around London. The three designs read: Don't Vote: Engage With Politics!; Don't Vote: Spoil Your Ballet!; and Don't Vote: Take to

the Streets! The posters feature a url that links to a page debunking the voting system and giving reasons why citizens should boycott it; an anonymous member of the Special Patrol Group gives an interview explaining the action to *Huck* magazine.[120]

DISMALAND & DSEI

The Special Patrol Group are invited to Banksy's Dismaland exhibition. On site they give tutorials in subvertising to visitors, using a bus stop ad-cabinet that has been installed especially for this purpose. They also make available the Ad Space Hack Pack, which contains the three tools needed to open most bus stops in the UK, as well as a guide to how to use them. Over 2,000 sets are sold during Dismaland's five-week run.

During the course of Dismaland, the Department for Security and Defence and Security Equipment International exhibition happens at the Excel Centre. The arms fair is widely protested every year. Artists from Dismaland—Darren Cullen, *STRIKE! Magazine*, Matt Bonner, and Barnbrook Studio—create designs that are installed in bus stops around London and on London Underground advertising spaces. Over 300 designs are installed and the action is featured by several major news outlets.[121]

GLASTONBURY 2016

Special Patrol Group is invited to be part of Glastonbury Festival. An advertising cabinet is installed on site as part of a bus stop installation, which features brand designs subverted with the "Advertising Shits in Your Head" slogan. The group also use the festival to launch their international Ad Hack Manifesto.[122] When Glastonbury ends, the group install the ad-cabinet in DIY Space

for London (an arts venue, activism space, and co-operative) where it is used for training others in ad hacking workshops.

SUBVERTISERS FOR LONDON

Special Patrol Group's latest campaign sees them re-imagining advertising spaces on the London Underground—particularly in terms of who gets to occupy them. Using the tagline "Subvertisers for London—Public Space Matters" in subverted Transport for London branding, the group have made templates available for artists and designers to work with campaigns that wouldn't normally have access to these premium spaces of public communication. They've then been printing the new designs and distributing them freely at subvertising workshops, so the installs themselves are carried out anonymously, autonomously, and horizontally.

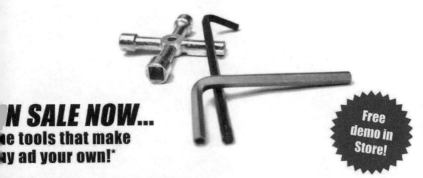
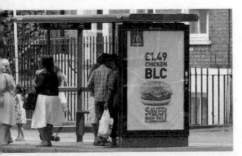
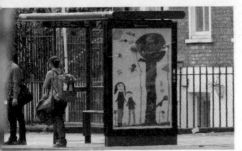

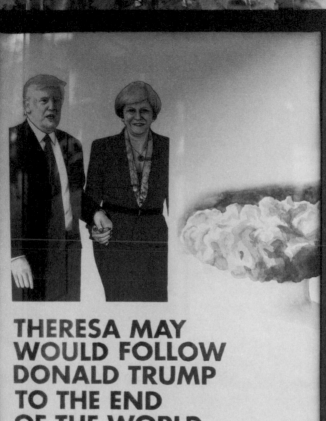

THERESA MAY WOULD FOLLOW DONALD TRUMP TO THE END OF THE WORLD.

VOTE FOR A NUCLEAR SUICIDE-PACT
VOTE FOR SELLING THE NHS
VOTE FOR ARMS SALES TO TYRANTS
VOTE FOR STARVING CHILDREN
VOTE FOR THERESA MAY

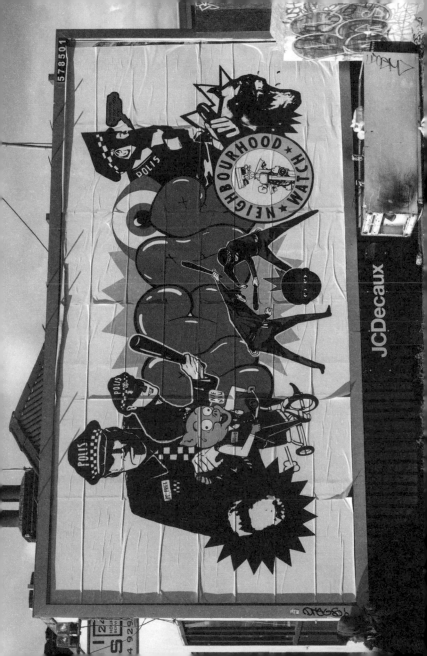

It's as if someone were out there making up pointless jobs just for the sake of keeping us all working.

#bullshitjobs

Important announcement

Travelling on the DLR from 15th to 18th September?

This September, a swarm of arms dealers will be descending on the DLR. Travelling to The ExCeL Centre to attend **DSEI**, the world's biggest Arms Fair. These visitors make huge amounts of money from weapons and equipment that kill people in wars all over the world. **Your taxes help pay for it.** Customers are requested to help stop the arms fair.

WARLORDS OF LONDON

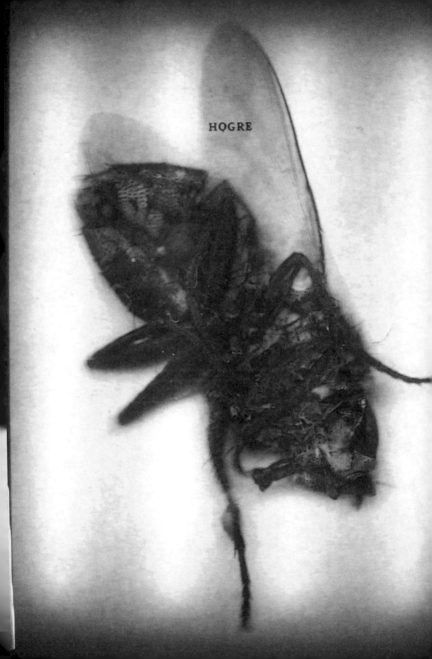

HOGRE

Italian street artist Hogre was best known for his stencil work but, after moving to London in 2015, he quickly discovered subvertising... and grabbed the billboards by the horns. Before long he was the capital city's most prolific subvertiser—his subverted billboards and bus stops became ubiquitous around southeast London, particularly.

As he had grown increasingly weary of street art and stencilling walls, subvertising offered Hogre a way to go on the attack again:

> *"I had this idea of subvertising already, without knowing how it would work or whatever. Already in Rome I could clearly see that a change of medium was necessary. When I moved to London, I came across Special Patrol Group straight away, of course, because I already had my eyes open to the subject. Then I found their amazing [Ad Space] Hack Pack, tried to access some cabinets, and it was done!"[123]*

As with his stencil-work, Hogre's subvertising is grounded in and informed by his anarchist outlook. He's wary of labelling himself an artist and claims to be no more wedded to subvertising as a medium than stencilling, instead seeing both as merely tools to express himself, his beliefs, and his creativity. There's a range of opinion in the subvertising movement about whether work should be presented anonymously or claimed by its creator;

Hogre is unequivocal:

> *"It's important in any political struggle to not provide an identity, not just for legal reasons, but because every new identity, every new style, every rebel attitude is easy to reproduce for the market, and then easy to be sold. That's also why I enjoy using different styles and experiment with different mediums, to avoid generating images that are all the same. Subvertising works better if you can't tell straight away if it is subvertising or not. It has to be illegal, of course, but it also has to be sneaky."[124]*

MORAL PANIC

In June 2017, Hogre was part of the Crack International Festival of Drawing at the squatted Forte Prestino in Rome, Italy, where he was joined by fellow subvertisers Special Patrol Group, Double Why, and Illustre Feccia. Together they put on a subvertising workshop that offered attendees instruction on the practical aspects of ad takeovers, and an opportunity to work together on updating some pre-acquired 6-sheet adverts.

Later the group went out and replaced adverts in Rome with the designs that had been created at the afternoon's workshop, as well as their own designs, printed in advance. Special Patrol Group put up Italian versions of the Ad Hack Manifesto; Hogre and Double Why installed a number of posters that referenced the child abuse scandals in the Catholic Church.

When they were spotted, these designs were confused for real adverts and sparked a national scandal—furious complaints were made to the city's tram operator, who owned the spaces, and angry comment pieces written in the press. Eventually Hogre was

tracked down and arrested in an internet cafe in Rome, and both he and Double Why were interrogated by the police; only Hogre was charged—with blasphemy.

The arrests and blasphemy charge precipitated Hogre and Double Why's first subvertising gallery show: Moral Panic. The pair described it as a tongue-in-cheek attempt to sell screen prints of the offending pieces, so that the Italian courts might consider them to be art and not mere blasphemous vandalism. At the time of writing Hogre remains at large, awaiting a court date.

CONTEST ROYALTY

Along with fellow Italian subvertisers Illustre Feccia and Double Why, Hogre curated an open-submission anti-monarchy subvertising project, timed to coincide with the Royal Wedding in May 2018.

The project aimed to combat

"verticalizations of power such as monarchy and patriarchy. It is created by anarchists of different ethnicities and genders. Collectively we organize art installations and actions to put into discussion and destroy the idea of royalty, which necessarily implicate subjection and inequality."[125]

THERE'S THE HOGRE AND THEN THERE'S THE CRAP

i'm lovin' it

BBQ
★ CHRIST
Legend
Deluxe

0114 0364

JCDecaux

COMING SOON TO A USELESS EMPTY BUILDING NEAR YOU

THE REALITY SHOW WHERE *YOU* GET TO STEAL FROM THE LANDLORDS

SQUAT THE LOT

FIND MORE INFO ABOUT HOW TO CRACK PROPERTIES, BUILD BARRICADES
FUCK UP THE BAILIFFS AND COLLAPSE THE HOUSING MARKET
AT PRACTICAL SQUATTING NIGHT

ECCE HOMO

&rectus

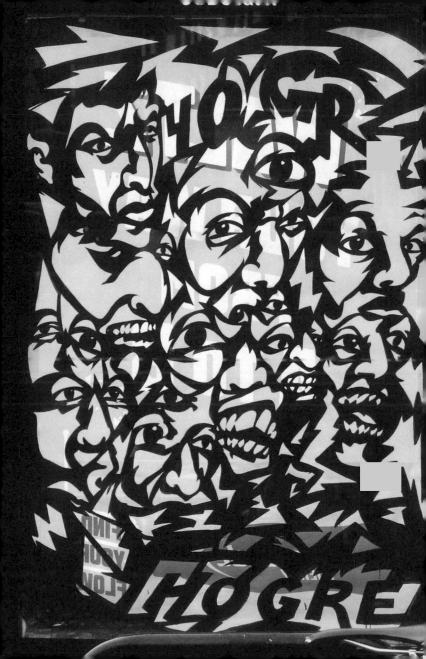

ART IN AD PLACES

Art in Ad Places is the brainchild of RJ Rushmore and Caroline Caldwell, who are also the brains behind the Vandalog street-art site. The New York City duo were well-placed to commit a year-long subverting project that put art in advertising places once a week, every week, in 2017.

They say the project was "sort of hilariously inspired by a Brazilian butt-lift billboard"[126] that was erected on their block—forcing them to see it every day, much to their annoyance. Artist and illustrator Caroline had already considered the way women particularly are misrepresented through advertising in her work (she's the author of the aphorism "In a society that profits from your self-doubt, liking yourself is a rebellious act"). Determined to have their revenge on the butt-lifters, they decided it would be best served as part of a broader campaign against advertising generally.

Launching in January 2017, Art in Ad Places set out to install 52 different designs in phone boxes in New York over the course of the year. The artworks were documented and displayed on a dedicated website, which also offered its audience advice on carrying out their own actions (continuing the theme of subverting activists attempting to democratise the practice).

Art in Ad Places decided early on that the artists selected would not necessarily be from the existing street art or subverting scenes, because they wanted to engage with different audiences. This meant there's been a wide range of artists involved, ranging

from Shepard Fairey, Molly Crabapple and the Guerrilla Girls to Parker Day, Noel'le Longhaul and Heather Benjamin.

Though the images used were not always political in content, RJ and Caroline know subvertising itself can be considered a political act, so both have deliberately chosen not to carry out the project anonymously, or under a pseudonym (as is common amongst street artists and subvertisers). They hope this makes it easier for more people to access and engage with, as Caroline further explains:

> *"In some cases, anonymity is important, even essential. For us, on this project, putting our names and faces out there helped bring the story to an audience beyond the street-art world, and made journalists more open to speaking with us. Everybody interacts with ads, not just street art fans. Presenting ourselves as real people helped make our complaints (and our activism) relatable to a broad audience."*[127]

Every takeover has been captured by renowned street-art photographer Katherine "Luna Park" Lorimer, a collaborator on the project. This has helped Art in Ad Places have a much wider audience than just those that view it in the street—the project has garnered a lot of mainstream coverage. Although the project is slick, and consciously uses the tools of promotion, RJ explains that they've tried to create an 'ethical spectacle':[128]

> *"Advertisers already understand how to influence people, how to get them excited. Hollywood understands it. Why re-invent the wheel when you can just use their market-tested strategies against them? What can we learn from Hollywood and the ad industry, in order to do things that are actually positive and ethical? There's a lot that you can take, and still be within those boundaries."*[129]

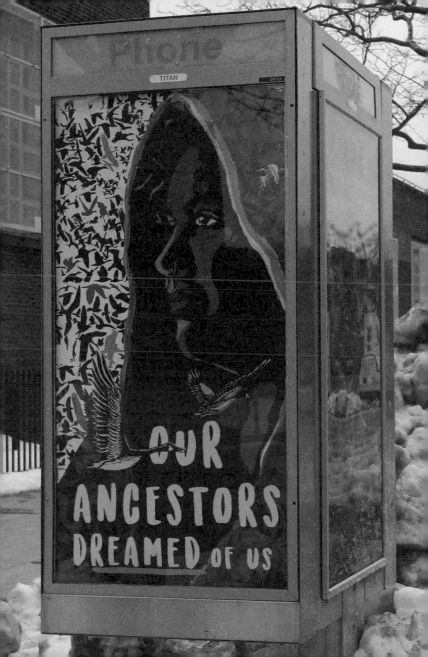

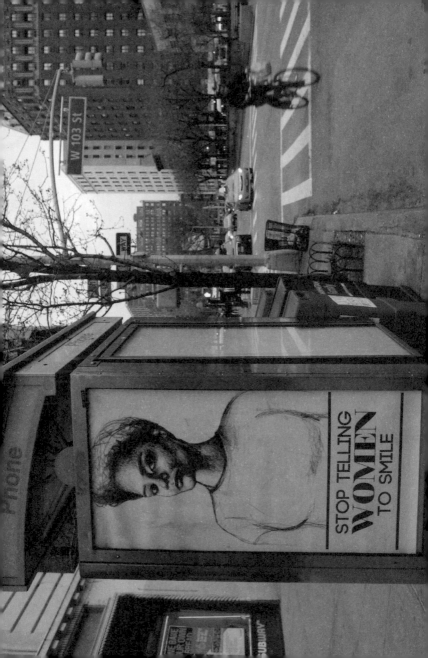

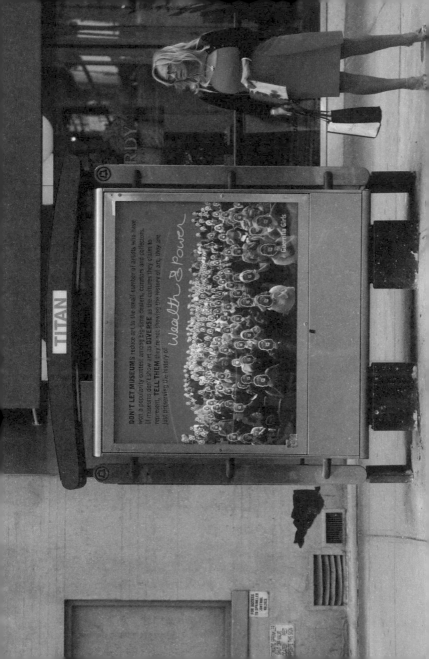

DON'T LET MUSEUMS reduce art to the small number of artists who have won a popularity contest among big-time dealers, curators and collectors. If museums don't show art as DIVERSE as the cultures they claim to represent, TELL THEM they're not showing the history of art, they are just preserving the history of

Wealth & Power

Guerrilla Girls

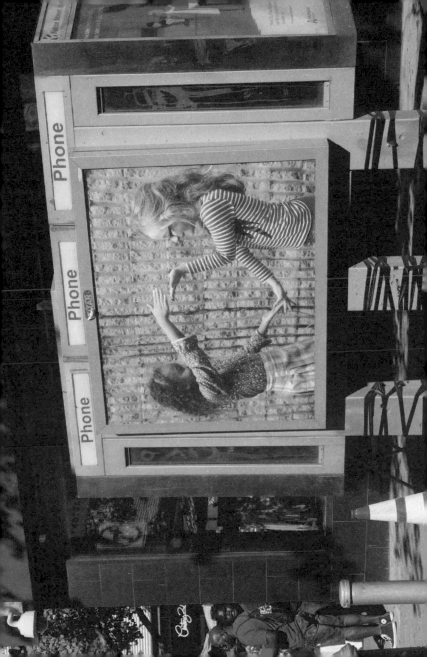

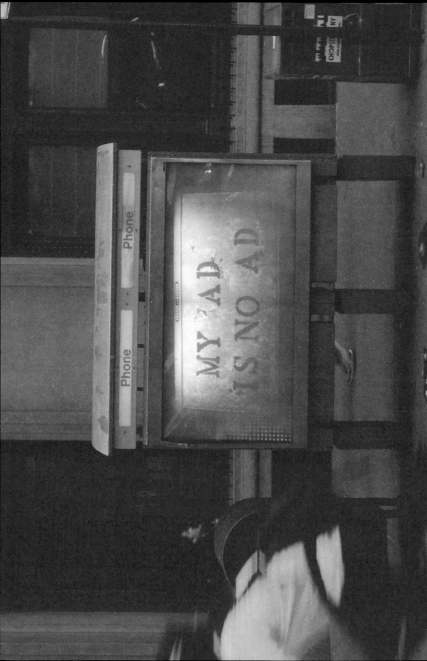

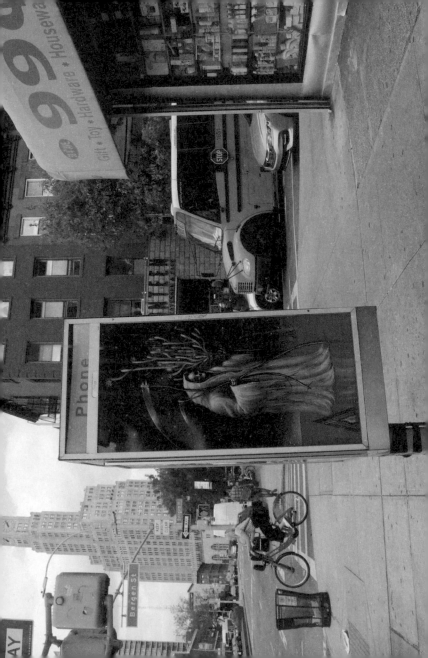

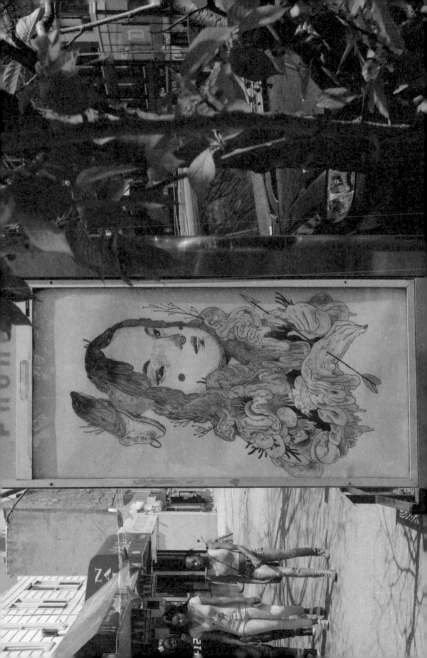

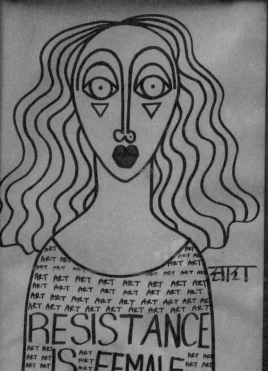

RESISTANCE IS FEMALE

Resistance Is Female hit the streets in the whirlwind following Donald Trump's election as president and as a direct response to his inauguration. The creators specifically cite the 2017 Women's March on Washington as their inspiration point and say they wanted to capitalise on the anger that was in the air and make sure it was visually represented on the streets.

The anonymous creators of the project are both practicing artists who live in New York. The founding member of the group initially started working alone—installing artwork on behalf of his female friends—but quickly realised he needed to bring in more people. Today the group is a collective of around ten female artists, who contribute artwork, select submitted pieces for display, and carry out the illicit installations together.

Like Art in Ad Places, Resistance Is Female utilises the ubiquitous NYC phone booth for their installations. They too wear high-visibility vests when carrying out their takeovers in public and say the actual installations "don't take any time at all really, when it boils down to it. If you have trouble, it's five minutes tops."[130] The group usually go out once a week and put new pieces up, "just to keep things fresh and keep stuff moving."[131]

The longevity of the installations can vary from less than a day to as much as two months, and there seems to be no pattern to what will stay up where or for how long. So documentation is important, and one of the group will take photos while another is

carrying out the installation. The photos are then shared though Instagram, with the hashtag #ResistanceIsFemale collecting and connecting everything together.

Most of the art is selected through an open-submissions process. The group say that they tend to pick pieces that are striking or bold, and all the pieces must bear the slogan "Resistance Is Female." The founder of the project says he deliberately chose an existing slogan because they didn't want to use "anything that was too own-able."[132] Instead, they hope to be a vehicle for rage that anyone can access.

They see subvertising as activism and say they're motivated by reclaiming public space and "fucking with the system."[133] Resistance Is Female also acts as an ongoing, positive propaganda campaign. When asked what they'd like the outcome of their project to be, they say: "We'd like that message out there as a constant encouragement, so when anyone's having a shitty day at work or whatever, they see the message and they're stoked again, y'know? For us, it's like a message of encouragement, for people to keep fighting."[134]

They haven't planned an end point to the project. As long as they're doing the back-end administrative and curatorial work, they hope they'll always have work to show:

> *"We don't have a set time frame for it but I think we would like to keep it going. If people stop submitting work and we don't have any more posters, then I guess that's that—but hopefully it will just get bigger."*[135]

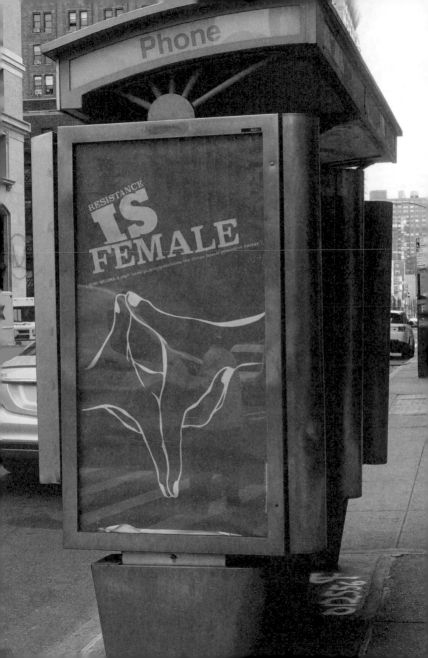

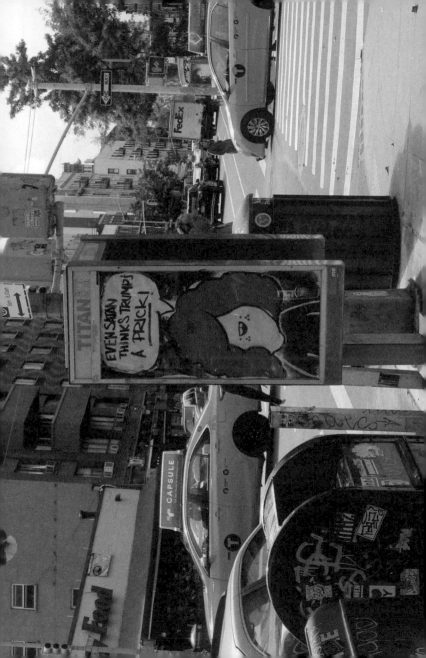

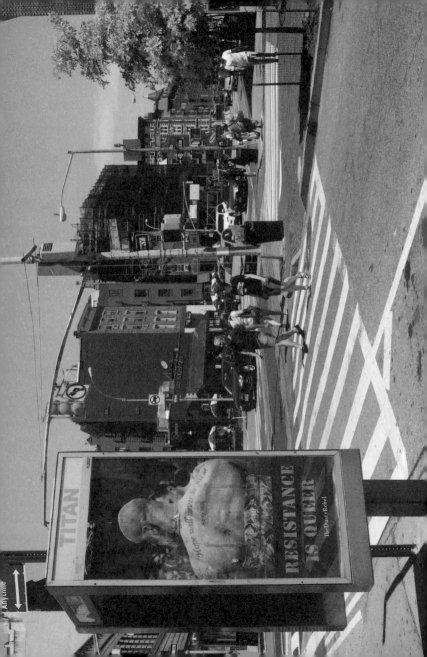

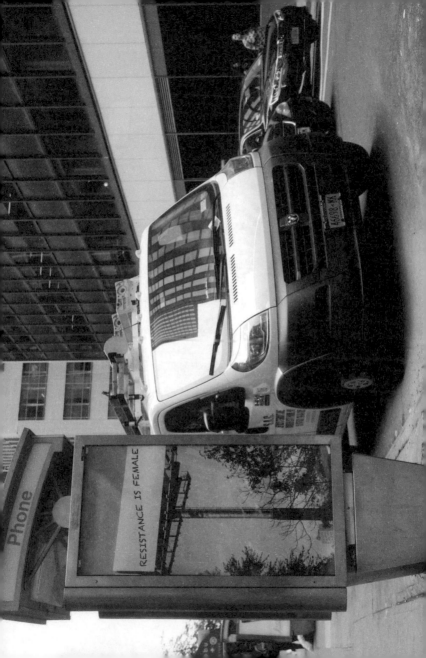

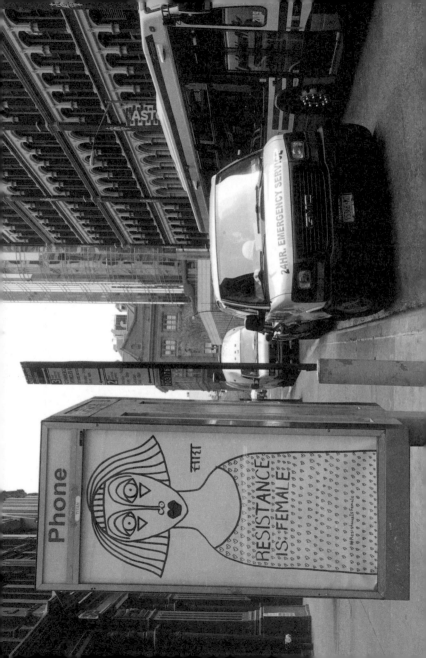

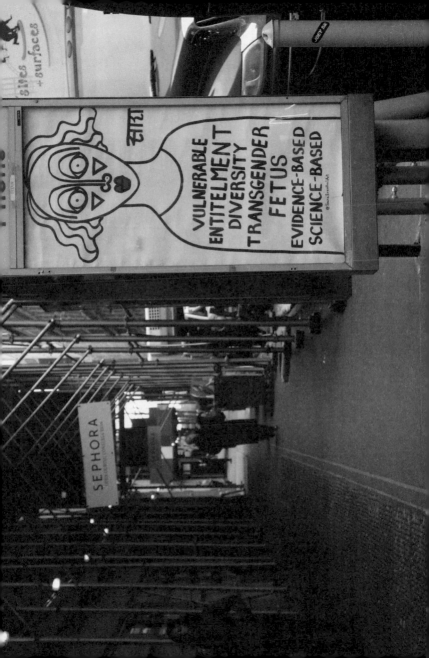

APPENDIX

INTERNATIONAL SUBVERTISERS

Proyecto Squatters
Argentina
proyectosquatters.blogspot.com

Les Deboulonneurs
France
deboulonneurs.org

Resistance a l'Agression Publicitaire (RAP)
France
antipub.org

Dies Irae
Germany
facebook.com/nervtjeden

Vermibus
Germany
vermibus.com

AutoEnganys
Spain
facebook.com/autoenganys

ConsumeHastaMorir
Spain
letra.org/spip

Adblock Bristol
UK
adblockbristol.wordpress.com

Brandalism
UK
brandalism.org.uk

Protest Stencil
UK
@protestencil

Special Patrol Group
UK
@specialpatrols

Public Ad Campaign
United States
publicadcampaign.com

PHOTO CREDITS

PREFACE

Burning Flag *p.4*
Photo credit: Charlotte England, 2017

INTRODUCTION

Fuck Work *p.6*
Artist: Josh MacPhee after Atelier Populaire
Photo credit: Thomas Dekeyser, 2018

Untitled *p.9*
Documentation of an anti-advertising action in the Paris Metro in 2003
Photo credit: Stop Pub, 2003

Untitled *p.13*
Documentation of an anti-advertising action in the Paris Metro in 2003
Photo credit: Stop Pub, 2003

AD HACK MANIFESTO

Ad Hack Manifesto *p.14*
Artist: Special Patrol Group, 2016
Photo credit: Special Patrol Group, 2016

**PART ONE:
ADVERTISING SHITS IN YOUR HEAD**

Total Propaganda *p.18*
Poster from Special Patrol Group's Total Propganda campaign
Photo credit: Special Patrol Group, 2015

Advertising Shits In Your Head *p.24*
TfL subverted Ad Hack Manifesto poster
Artist: Special Patrol Group, 2016

Your Eyes Read This Silently *p.29*
Poster from Brandalism's 2014 6-Sheet action
Photo credit: Brandalism, 2014

Movie Stars or War *p.30*
Artist: Robert Montgomery
Photo credit: Robert Montgomery, 2009

Values *p.34*
Diagram showing Schwartz's universal values
Credit: Public Interest Research Centre (PIRC), 2016. Values, Framing and Advertising

Intrinsic vs Extrinsic Values *p.35*
Diagram showing intrinsic and extrinsic values in opposition
Credit: Alexander, J; Crompton, T; Shrubsole, G, 2011. Think of me as Evil? Opening the Ethical Debates in Advertising

Social Cleansing *p.37*
Artist: Dr. D. Photo Credit: Dr. D, 2015

The Visual Realm is a Public Realm *p.38*
TfL subverted Ad Hack Manifesto poster
Artist: Special Patrol Group, 2016

PART TWO:
STRATEGIES FOR RESISTANCE

Outdoor Advertising Should Be Banned *p.46*
TfL subverted Ad Hack Manifesto poster
Artist: Special Patrol Group, 2016

What a Hunt – Donald Trump *p.50*
Artist: Dr. D. Photo Credit: Dr. D, 2016

The Police Talk To You *p.55*
Artist: Josh MacPhee after Atelier Populaire
Photo credit: Thomas Dekeyser, 2018

Dismaland Demonstration *p.56*
An anonymous SPG operative gives a subvertising demonstration at Dismaland. Photo credit: Scarlett Brown, 2015

Yeah, We Got Keys For That *p.59*
Public Access Campaign keys
Photo credit: Jordan Seiler, 2016

How to Hack into Bus Stop Advertising Spaces *pp.60–61*
Guide to hacking bus stop spaces, subverted TfL design
Artist: Special Patrol Group, 2016

How to Hack into this Bus Stop Advertising Space *p.63*
Artist: Special Patrol Group, 2016
Photo credit: Special Patrol Group, 2018

Billboard installation *p.67*
A member of Brandalism installs a billboard
Photo credit: Brandalism, 2012

Arms Dealers Not Welcome In London *p.69*
Billboard installation as part of the campaign to stop DSEI
Artist: Matt Bonner, 2018
Photo credit: Special Patrol Group, 2018

Art In Ad Places phone booth installation *p.70*
Photo credit: Photo credit: César Martínez Barba, 2018

Not Vandalism *p.74*
TfL subverted Ad Hack Manifesto poster.
Artist: Special Patrol Group, 2016

PART THREE:
THE SUBVERTISERS

Public Ad Campaign

Infinity Phones 1 *p.80*
Artist & Photo credit: Jordan Seiler

Infinity Phones 2 *p.85*
Artist & Photo credit: Jordan Seiler

Presse *p.86*
Jordan Seiler, Collisions series, Paris. Photo credit: Jordan Seiler

Collisions *p.87*
Jordan Seiler, Collisions series, Paris. Photo credit: Jordan Seiler

Musik *p.88*
Jordan Seiler, Collisions series. Photo credit: Jordan Seiler

Collisions *p.89*
Jordan Seiler, Collisions series. Photo credit: Jordan Seiler

NYSAT1 *p.90*
Citizens taking part in Jordan Seiler's NYSAT project
Artist & Photo credit: Jordan Seiler

NYSAT2 *p.91*
Citizens taking part in Jordan Seiler's NYSAT project
Artist & Photo credit: Jordan Seiler

NOAD1 *p.92*
Images from Jordan Seiler's NOAD app
Artist & Photo credit: Jordan Seiler

NOAD2 *p.93*
Images from Jordan Seiler's NOAD app
Artist & Photo credit: Jordan Seiler

TOSAT Takeover *p.94*
Artist: Skullohone. Photo credit: Jordan Seiler, 2010

Jordan subvertsing *p.95*

Brandalism

Riot City *p.96*
Artist: Bill Posters
Photo credit: Brandalism, 2014

We're Sorry That We Got Caught *p.101*
Artist: Barnbrook & Friends
Photo credit: Brandalism, 2016

Just Loot It *p.102*
Artist: Bill Posters
Photo credit: Brandalism, 2012

Markets *p.103*
Artist: Peter Kennard
Photo credit: Brandalism, 2012

Untitled *p.104*
Artist: Paul Insect
Photo credit: Brandalism, 2012

Untitled *p.105*
Artist: Peter Willis
Photo credit: Brandalism, 2012

Hi-viz hanging out to dry *p.106*
Photo credit: Brandalism, 2012

Install team at work *p.107*
Photo credit: Brandalism, 2012

Unity *p.108*
Artist: Aida Wilde
Photo credit: Brandalism, 2012

Untitled *p.109*
Photo credit: Brandalism, 2015

Alice in Gasland *p.110*
Photo credit: Brandalism, 2015

Part of the Problem *p.111*
Artist: Matt Bonner
Photo credit: Brandalism, 2015

Special Patrol Group

Total Propaganda *p.112*
Artist: STRIKE! Magazine
Photo credit: Matt Bonner, 2015

Dismaland Programme *p.117*
Page 2 - advert for Ad Space Hack Packs
Credit: Banksy, 2015

No Pride in War *p.118*
Artist: Matt Bonner
Photo credit: Special Patrol Group, 2016

Harry Potter *p.119*
Artist: Matt Bonner and Legally Black
Photo credit: Special Patrol Group, 2018

Don't Vote *p.120*
Artist: STRIKE! Magazine
Photo credit: Special Patrol Group, 2015

To the End of the World *p.121*
Artist: Darren Cullen
Photo credit: Special Patrol Group, 2017

ACAB *p.122*
Artist: STRIKE! Magazine
Photo credit: Special Patrol Group, 2017

Bobbies on the Beatings *p.123*
Artist: Marco Bevilacqua
Photo credit: Special Patrol Group, 2017

Total Cunts *p.124*
Artist: Peter Willis
Photo credit: Special Patrol Group, 2014

Mother's Love *p.125*
Artist: Darren Cullen
Photo credit: Special Patrol Group, 2018

Bullshit Jobs *p.126*
Featuring a quote from David Graeber's STRIKE! Magazine article "On the Phenomenon of Bullshit Jobs"
Photo credit: Special Patrol Group, 2014

Warlords of London *p.127*
Artist: Matt Bonner
Photo credit: Special Patrol Group, 2015

Hogre

Fly *p.128*
Artist: Hogre
Photo credit: Hogre

Then There's the Crap *p.132*
Artist: Hogre
Photo credit: Hogre

No Change *p.133*
Artist: Hogre
Photo credit: Hogre

BBQ Christ Legend *p.134*
Artist: Hogre
Photo credit: Hogre

A Little Happiness *p.135*
Artist: Hogre
Photo credit: Hogre

Squat the Lot 1 *p.136*
Artist: Hogre
Photo credit: Hogre

Squat the Lot 2 *p.137*
Artist: Hogre
Photo credit: Hogre

Ecce Homo *p.138*
Artist: Hogre
Photo credit: Hogre

End Deportations *p.139*
Artist: Hogre
Photo credit: Hogre

Self-Portrait 1 *p.140*
Artist: Hogre
Photo credit: Hogre

Self-Portrait 2 *p.141*
Artist: Hogre
Photo credit: Hogre

Art in Ad Places

Blue Lady *p.142*
Artist: Parker Day
Photo credit: Luna Park, 2017

Our Ancestors Dreamed of Us *p.145*
Artist: Jess X Snow & Jordan Alam
Photo credit: Luna Park, 2017

Stop Telling Women to Smile *p.146*
Artist: Tatyana Fazlalizadeh
Photo credit: Luna Park, 2017

Untitled *p.147*
Artist: Ouizi
Photo credit: Luna Park, 2017

Wealth and Power *p.148*
Artist: Guerrilla Girls
Photo credit: Luna Park, 2017

Hope and Promise *p.149*
Artist: Jamel Shabazz
Photo credit: Luna Park, 2017

Jealous Lover I *p.150*
Artist: Heather Benjamin
Photo credit: Luna Park, 2017

Untitled *p.151*
Artist: LaLa Abaddon
Photo credit: Luna Park, 2017

MY AD IS NO AD *p.152*
Artist: John Fekner
Photo credit: Luna Park, 2017

Untitled *p.153*
Artist: Martha Cooper
Photo credit: Luna Park, 2017

Untitled *p.154*
Artist: Jeff Soto
Photo credit: Luna Park, 2017

The Ecstasy of St. Katsuhiro Otomo *p.155*
Artist: Nomi Chi
Photo credit: Luna Park, 2017

Resistance Is Female

Untitled *p.156*
Artist: Sara Erenthal
Photo credit: Luna Park, 2017

Untitled *p.159*
Artist: Desha Creative
Photo credit: Luna Park, 2017

Untitled *p.160*
Artist: Abe Lincoln Jr.
Photo credit: Luna Park, 2017

Resistance Is Queer *p.161*
Artist: The Dusty Rebel
Photo credit: Luna Park, 2017

Untitled *p.162*
Artist: Gigi Chen
Photo credit: Luna Park, 2017

Untitled *p.163*
Artist: Celout
Photo credit: Luna Park, 2017

Girl Power *p.164*
Artist: Kiana (age 11)
Photo credit: Luna Park, 2017

Untitled *p.165*
Artist: Valerie Lobasso
Photo credit: Luna Park, 2017

Untitled *p.166*
Artist: Luna Park
Photo credit: Luna Park, 2017

Untitled *p.167*
Artist: MythNY
Photo credit: Luna Park, 2017

Untitled *p.168*
Artist: Sara Erenthal
Photo credit: Luna Park, 2017

Untitled *p.169*
Artist: Sara Erenthal
Photo credit: Luna Park, 2017

Long Live the Market *p.170*
Photo credit: Brandalism, 2014

Ad Nauseum *p.172*
Photo credit: Brandalism, 2014

Titanic *p.183*
Artist: Matt Bonner and Legally Black
Photo credit: Special Patrol Group, 2018

Install action-shot *p.184*
Photo credit: Jordan Seiler

Untitled *p.187*
Artist: Millo
Photo credit: Brandalism, 2016

Your Eyes Read This Silently *p.188*
Poster from Brandalism's 2014 6-Sheet action
Photo credit: Brandalism, 2014

Stop Looking at Me *p.204*
Photo credit: Jordan Seiler

BIBLIOGRAPHY

BOOKS ON ADVERTISING

Bernays, E., 1928. *Propaganda*. New York: Ig Publishing [2005].

Galbraith, J.K., 1958. *The Affluent Society*. London: Penguin [1999].

Flood, C., 2012. *British Posters: Advertising, Art and Activism*. London: V&A.

ARTICLES BY SUBVERTISING ACTIVISTS

Billboard Liberation Front, *The Art and Science of Billboard Improvement* (pamphlet).

Posters, B., 2014. *Advertising Shits in Your Head*. STRIKE! Magazine, Issue 7 Sep-Oct 2014.

ARTICLES ON ADVERTISING

Cronin, A., 2010. *Advertising, Commercial Spaces and the Urban*. Palgrave Macmillan UK.

Gillet, R., 2013. *Confronting the Outdoor Advertising Industry: A Critical Assessment of Its Impacts and Opponents*.

Heath, R. & Nairn, A., 2004. *Measuring Affective Advertising: Implications of Low Attention Processing on Recall*. University of Bath School of Management Working Paper Series.

Jhally, S., 2000. *Advertising at the Edge of the Apocalypse*. www.sutjhally.com/articles/advertisingattheed

ARTICLES ON PRODUCTION OF SPACE

Harvey, D., 2008. *The Right to the City*. New Left Review, 53.

Iveson, K., 2012. *Branded Cities: Outdoor Advertising, Urban Governance, and the Outdoor Media Landscape*. Antipode, Vol. 44, No. 1.

Power, N., 2014. *The Public, The Police and the Rediscovery of Hate!* STRIKE! Magazine.

ARTICLES ON SUBVERTISING/ DETOURNEMENT

Debord, G. *For a Revolutionary Judgement of Art.* Situationist International Anthology.

Dekeyser, T., 2016. *Distorting Urban Habits: Subvertising and the Re-Engineering of Urban Affect.* Association of American Geographers lecture.

Gilman-Opalsky, R., 2013. *Unjamming the Insurrectionary Imagination: Rescuing Detournement from the Liberal Complacencies of Culture Jamming.* Theory in Action, Vol. 6, No. 3.

Lekakis, Eleftheria J., 2016. *Discursive Political Consumerism for the Environment: Brandalism, Culture Jamming and the Logic of Appropriation.* Paper presented to European Consortium for Political Research (ECPR).

Smith-Anthony, A. & Groom, J., 2015. *Brandalism and Subvertising: Hoisting Brands with Their Own Petard?* Journal of Intellectual Property Law & Practice, Vol. 10, No. 1.

NGO REPORTS ON THE EFFECTS OF ADVERTISING

Alexander, J., Crompton, T., Shrubsole, G., 2011. *Think of Me as Evil? Opening the Ethical Debates in Advertising.*

Gannon, Z. & Lawson, N., 2010. *The Advertising Effect: How Do We Get the Balance of Advertising Right?* Compass.

Public Interest Research Centre (PIRC), 2016. *Values, Framing and Advertising.*

NOTES

1. Sut Jhally, 2000. "Advertising at the Edge of the Apocalypse."
http://www.sutjhally.com/articles/advertisingattheed/

2. London Street Art Design/Anon, 2014. "*LSD Magazine* Interviews
Public Ad Campaign." http://londonstreetartdesign.co.uk/lsdmagazine-
interviews-public-ad-campaign

3. Brandalism, 2014. "Why Brandalise? Brandalism."
http://www.brandalism.org.uk/why-brandalise
"As well as a peddler of goods, Bernays served the American government's
propaganda efforts during the First World War. Deeply suspicious of
mass democracy, he felt the public mind had to be guided for its own
good. Mass consumption was the tonic, providing not only a safe outlet
for the dangerous emotional energies of the populace, but a vital boost to
industry. Economic growth is the fundamental aim to which our societies
have been engineered, and for the economy to produce more, we need to
consume more."

4. Adam Curtis, *Century of the Self*, 2002. RDF Television/BBC.

5. Edward Bernays, 1928. *Propaganda* (New York: Ig Publishing, 2005), 48.

6. Bernays, *Propaganda*, 57. "A desire for a specific reform, however
widespread, cannot be translated into action until it is made articulate, and
until it has exerted sufficient pressure upon the proper lawmaking bodies.
Millions of housewives may feel that manufactured foods deleterious to
health should be prohibited. But there is little chance that their individual
desires will be translated into effective legal form unless their half-
expressed demand can be organized, made vocal, and concentrated upon
the state legislature or upon the Federal Congress in some mode which
will produce the results they desire. Whether they realise it or not, they call
upon propaganda to organise and effectuate their demand."

7. Bernays, *Propaganda*, 48. "I am aware that to many minds the word
propaganda carries to many minds an unpleasant connotation. Yet

whether, in any instance, propaganda is good or bad depends upon the merit of the cause urged, and the correctness of the information published."

8. Bernays, 37.

9. Bernays, 57. "It might be better to have, instead of propaganda and special pleading, committees of wise men who would choose our rulers, dictate our conduct, decide upon the best types of clothes for us to wear and the best kind of foods for us to eat. But we have chosen the opposite method, that of open competition. We must find a way to make free competition function with reasonable smoothness. To achieve this society has consented to permit free competition to be organised by leadership and propaganda."

10. Bernays, 39. "I believe that competition in the future will not only be an advertising competition between individual products or between big associations, but that it will in addition be a competition of propaganda."

11. Brandalism, 2016. "Brandalism COP 21." http://www.brandalism.org.uk/brandalism-cop21

12. Bill Posters, 2014. "Advertising Shits in Your Head." *STRIKE! Magazine*, no. 7 (September–October 2014): 16.

13. Posters, "Advertising Shits in Your Head."

14. Philip Kleinfeld, 2015. "We Spoke to a Dismaland Artist Who's Behind the Anti-Arms Dealer Posters Going Up All Over London." *VICE*. https://www.vice.com/en_uk/article/jmadj8/dsei-posters

15. Owen Gibson, 2005. "Shopper's Eye View of Ads that Pass Us By." *Guardian*. https://www.theguardian.com/media/2005/nov/19/advertising.marketingandpr.

16. Or even that it has a positive affect on the consumer: "People love outdoor advertising because of the way it entertains and amuses, because it brings a smile to the dreariest of tube journeys between Cockfosters and Piccadilly." Arwa Mahdawi, 2015. "Can Cities Kick Ads? Inside the Global Movement to Ban Urban Billboards." *Guardian*. https://www.theguardian.com/cities/2015/aug/11/can-cities-kick-ads-ban-urban-billboards.

17. Rory Sutherland, 2010. "We Can't Run Away from the Ethical Debates in Marketing." *Market Leader*, Q1, 59. "The truth is that marketing raises enormous ethical questions every day—at least it does if you're doing it right. If this were not the case, the only possible explanations are either that you believe marketers are too ineffectual to make any difference, or you believe that marketing activities only affect people at the level of conscious argument. Neither of these possibilities appeals to me. I would rather be thought of as evil than useless." [written as president of the Institute of Practitioners in Advertising (IPA)].

18. Gibson, "Shopper's Eye View of Ads That Pass Us By."

19. Robert Heath and Agnes Nairn, 2004. "Measuring Affective Advertising: Implications of Low Attention Processing on Recall." University of Bath School of Management Working Paper Series.

20. John Kenneth Galbraith, 1958. *The Affluent Society* (London: Penguin 1958 [1999]), 129. "As a society becomes increasingly affluent, wants are increasingly created by the process by which they are satisfied. This may operate passively. Increases in consumption, the counterpart of increases in production, act by suggestion or emulation to create wants. Expectation rises with attainment. Or producers may proceed actively to create wants through advertising and salesmanship."

21. Chulho Jung and Barry J. Seldon, "The Macroeconomic Relationship Between Advertising and Consumption." *Southern Economic Journal* 61 (1995): 557–87.

22. Jon Alexander, Tom Crompton, and Guy Shrubsole 2011. "Think of Me as Evil? Opening the Ethical Debates in Advertising," (Machynlleth: Public Interest Research Centre), 18. "Since human needs are finite, but human greed is not, economic growth can usually be maintained through the artificial creation of needs through advertising."

23. Zoe Gannon and Neal Lawson, *The Advertising Effect: How Do We Get the Balance of Advertising Right?* (London: Compass, 2009), 13. "In the UK as individuals we now owe a collective £1.3 trillion on credit cards, store cards, mortgages, and loans. This figure is around over the last decade; it stood at 105 percent just ten years ago. Our total individual borrowing is equivalent to a third of the UK's GDP, which in 2008 stood at £3.1 trillion."

24. Gannon and Lawson, *The Advertising Effect*. "To pay for our increasingly lavish consumer lifestyle there are two options: work harder and longer or borrow. We are doing both."

25. Brandalism, 2016. "Why Brandalise?."
http://www.brandalism.org.uk/why-brandalise

26. Gannon and Lawson, *The Advertising Effect*, 18.

27. Anne M. Cronin, 2010. "Advertising, Commercial Spaces and the Urban," 1.
http://www.research.lancs.ac.uk/portal/en/publications/-(8608315d-ea5e-4ac0-a319-6bd51341d814).html

28. London Street Art Design/Anon, "LSD Magazine Interviews Public Ad Campaign.""I don't think anyone is going to sit there and say advertising encourages a large portion of our more interesting goals for ourselves as a society, like community, taking care of our children correctly and education. Advertising doesn't address those things, it deals with our base needs, our ego, and our desire for purchase, so when you allow it to proliferate in that setting you are really saying that we are ok with having a society based on Hummers and diamond rings, and when you start to look at that issue you start to realise that maybe this is about defining the world we would really like to live in."

29. Posters. "Advertising Shits in Your Head," 16.

30. Jordan Seiler, 2016. "Sounds Like a Manifesto." *Public Ad Campaign Daily*.
http://daily.publicadcampaign.com/2016/03/sounds-like-manifesto.html
"This deception, taking place in public space, makes the offense all the more malevolent as our shared environment must function as a place in which collectivity can manifest. Instead the predominant messages and cultural values we enforce in public space actively appeal to our individuality and or commercial segmentation. True holistic visions of society that include the economic and social justice at the heart of real societal reform lie outside of capitalism and thus the corporate media agenda that we allow unfettered access to our shared pubic spaces."

31. Cronin, "Advertising, Commercial Spaces and the Urban," 10.

32. Posters. "Advertising Shits in Your Head," 16. "These studies are finally proving what many have suspected for decades: advertising affects and normalises attitudes, behaviors and values. Advertising doesn't just reflect culture, as the industry purports, it actively shapes our values. Could we therefore say that the control of our collective values remains with those who can afford it?"

33. Shalom Schwartz, 1992. "Basic Human Values: An Overview." https://www.researchgate.net/file.PostFileLoader. html?id=57239305217e20f6586c54d4&assetKey= AS% 3A356254875701248%401461949189017

34. Alexander, Crompton, Shrubsole, "Think of Me as Evil?," 24.

35. Alexander, Crompton, Shrubsole, 30. "The great majority of advertising money is spent in ways that appeal to extrinsic values—that is, values associated with lower motivation to address social or environmental problems. This is to be expected: the behavior sought as an output of almost all advertising is an act of consumption."

36. Alexander, Crompton, Shrubsole, 28.

37. Alexander, Crompton, Shrubsole, 31. "As these values are primed repeatedly, they are likely to be strengthened. This is likely to happen through an automatic route as well as an effortful route of cognitive processing. Through the automatic route, priming values strengthens links between environmental cues and these values in the way that information is stored in our memory (i.e., our schemas). This serves to strengthen these values automatically, even without awareness on the part of the person. In addition, through the effortful route, messages that strengthen existing values provide people with further proof that the values are indeed important and worth pursuing. Hence, through effortful cognitive thinking about these values and their importance, these values are strengthened and the environmental cues provide evidence and reasons for the importance of these values."

38. David Harvey, "The Right to the City." *New Left Review* 53 (September–October 2008): 32.

39. Bernays, *Propaganda*, 90.

40. Kurt Iveson, "Branded Cities: Outdoor Advertising, Urban Governance, and the Outdoor Media Landscape," *Antipode* 44, no. 1 (2012): 152. "Advertising spending is increasingly dominated by large multinational corporations who seek to advertise their many products and services across regional and global markets."

41. Catherine Flood, British Posters: *Advertising, Art and Activism* (London: V&A, 2012), 82.
"As graphic design writer Angharad Lewis puts it: 'If you can afford the big, prominent sites, you are tolerated and legalised, otherwise you are deemed beyond control, your message is torn down and you are criminalised.' In the view of Malcolm McLaren (former manager of the Sex Pistols): 'This seems to be about ensuring that control of culture remains with those who can afford it. To ban fly-posting will be another arrow in the heart of our ability as a society to accommodate contrary points of view.'"

42. Posters, "Advertising Shits in Your Head," 16. "It is important to consider here that the spaces reclaimed by artists are in public space, despite being privately owned and operated by multinational advertising corporations. There are hundreds of thousands of these spaces across the UK, but we have never consented to being pissed on from above by their messages and their branded advertisements. This is fundamentally different to the other forms of advertising that we come into contact with and have, to a greater extent, some agency over. We can choose to turn a page, a channel or install software on our computers to remove these trespassers on our visual realm. We have no such luxury concerning public space."

43. Jordan Seiler, 2015, "Public Access."
http://www.publicadcampaign.com/PublicAccess/Index.html
"Nearly every major metropolitan city has an active bus or trolley system. Over the years, this vital public service has become an integral part of the global outdoor advertising industry in the form of bus shelters and other municipal infrastructure. Chances are if a city has a meaningful surface transit, a select few global outdoor advertising companies will operate public amenities like bus shelters, for which they have the sole right to display for profit commercial advertising."

44. Mahdawi, "Can Cities Kick Ads?."

45. Mahdawi.

46. London Street Art Design/Anon, "LSD Magazine Interviews Public Ad Campaign."

47. Kurt Iveson, "Branded Cities," 170. "Even if we had no political concerns about the impact of advertising-funded urban infrastructure, the sustainability of the funding model is open to question. Just because street furniture is provided at no cost to urban authorities does not make it "free"— expenditure on advertising makes up part of the cost of products which are advertised, so "we" are still paying for it as consumers if not as tax payers."

48. Harvey, "The Right to the City," 23.

49. Harvey, 40. "One step towards unifying these struggles is to adopt the right to the city as both working slogan and political ideal, precisely because it focuses on the question of who commands the necessary connection between urbanization and surplus production and use. The democratization of that right, and the construction of a broad social movement to enforce its will is imperative if the dispossessed are to take back the control which they have for so long been denied, and if they are to institute new modes of urbanization. Lefebvre was right to insist that the revolution has to be urban, in the broadest sense of that term, or nothing at all."

50. Posters, "Advertising Shits in Your Head," 16.

51. Seiler, "Sounds Like a Manifesto." "By reclaiming our streets and demanding a public visual landscape that reflects the public's concerns over a commercial agenda, we call upon a prized and shared civic resource to host the revolution once again."

52. Posters, "Advertising Shits in Your Head," 17.

53. Thomas Dekeyser, 2015. "Hackpacks and the Right to the City: Some Thoughts." *Distorted Space*. https://distortedspace.com/2015/11/10/hackpacks-and-the-right-to-thecity-some-thoughts/. "Indeed, what if artists re-embed these spaces with their own brands, their stylish logos, seeking attention from the commodified arts industry, where then do the

politics of billboard distortion arrive? What kinds of worlds does it then open up to? Are we not, in this instance, devaluating any claims at seriously asserting our right to the city, in 'branding' it our own, once again, and following Michel Serres' conception, polluting urban space like jungle-animals bounding their physical territories?"

54. Posters, "Advertising Shits in Your Head," 16.

55. Mahdawi, "Can Cities Kick Ads?."

56. Mahdawi.

57. Mahdawi.

58. Mahdawi.

59. Iveson, "Branded Cities," 152.

60. Jordan Seiler, "Research interview." Vyvian Raoul.

61. Seiler, "Research interview." "In my own experience I've found that it's like a Hydra, you cut off one head and two more grow. There is far too much money to be had for the industry to just turn tail and run. No matter what sort of laws and regulations you pass... we have restrictions in New York and LA and they just ignore them and are willing to deal with the fines. This industry is inherently willing to break the law, their business model is based on it. This is why I think regulation's not a good final goal, it really has to be a societal shift that says this stuff hurts us, it needs to go away fully, and without that it's just gonna creep back in."

62. Flood, *British Posters: Advertising, Art and Activism*, 82. Catherine Flood has its emergence as much later than the 1970s and begins her account with the anti-globalisation movement and the inception of Adbusters in 1989: "At the same time anti-globalisation, in tandem with radical environmentalism, emerged as an umbrella movement for a new wave of world-wide activism in which the practices of corporate marketing and global branding were held up to scrutiny. The form of graphic protest most closely associated with anti-globalisation is 'subvertising,' whereby the advertisements or multinational brands are satirised by being doctored or spoofed. Adbusters, founded in 1989 in Vancouver, became a flagship organisation for this kind of creative resistance, propagating subvertising and 'culture jamming' around the world through its magazine, campaigns and competitions."

63. BUGA-UP, 2012. FAQs, http://www.bugaup.org/faq.htm. "In the 1970s in Australia, tobacco and other advertising was everywhere—indoor, outdoor, in cinemas and on television. Huge tobacco advertisements covered the sides of buildings, or blared from their rooftops. Freeways and roads had tobacco signs along the way. Billboards were at railway stations and between stops, in train carriages and on buses. The medical profession wrote submissions to have them removed, in vain. The visual environment had become dominated by advertising and the few regulations that existed were ineffective. Someone had to do something about it!"

64. BUGA-UP, 2012. FAQs, http://www.bugaup.org/faq.htm. "BUGA-UP was one of the earliest examples of culture jamming in the world, and certainly in Australia. Culture jamming is often seen as a form of subvertising and this was certainly a prime objective of BUGA-UP."

65. Billboard Liberation Front, date unknown. "History and Timeline." http://www.billboardliberation.com/history.html. "Glikk and Napier form the BLF and christen it by altering and improving 9 'Fact Cigarette' boards around San Francisco on Christmas Day. With the help of Simon Wagstaff (BLF's first press agent) they publicise their premier Billboard action for maximum exposure and impact."

66. *The Art and Science of Billboard Improvement* is the classic BLF text that is still in circulation today, both in print and online: http://www.billboardliberation.com/ArtAndScience-BLF.pdf.

67. Seiler, "Advertising Takeovers Practical Workshop." "Subvertising is the practice of altering, removing, or reversing of commercial outdoor media spaces that has seen an emergence over the last few years."

68. Posters, "Advertising Shits in Your Head," 16. "A networked culture, a 'movement of movements,' centered around global solidarity—a worldwide activism spawned by globalisation and driven by citizens, new media technologies and the expansion of art's urban context—has emerged in the last decade."

69. Thomas Dekeyser, 2015. "Why Artists Installed 600 Fake Adverts at COP 21." Distorted Space http://theconversation.com/why-artists-installed-600-fake-adverts-at-cop21-51925.

70. Bartlett, J., 2015. "The Climate Activists Who Secretly Replace Adverts with Artwork," *Telegraph*.
http://www.telegraph.co.uk/news/earth/paris-climate-change-conference/12063081/The-climate-activists-who-secretly-replace-adverts-with-artwork.html.

71. Richard Gilman-Opalsky, R., 2013. "Unjamming the Insurrectionary Imagination: Rescuing Detournement from the Liberal Complacencies of Culture Jamming," *Theory in Action* 6, no. 3 (July 2013): 5. "Culture jamming attempts to intervene in the visual landscape that shapes how we think, because culture jammers understand that everything we see sends us messages, that the visual landscape is not a neutral terrain."

72. Brandalism, "Why Brandalise?." Brandalism specifically cites the work of the Situationists as one of their inspirations: The Brandalism project started in 2012, as an extension of the guerilla art traditions of the twentieth century, and a manifestation of various elements influenced by agitprop, the Situationists and graffiti movements.

73. Gilman-Opalsky, "Unjamming the Insurrectionary Imagination," 1. "Detournement is political plagiarism, distortion, hijacking, or otherwise rerouting something against itself. For Debord, detournement was a revolutionary project 'undertaken within the present conditions of oppression, in order to destroy those conditions.'"

74. Gilman-Opalsky, "Unjamming the Insurrectionary Imagination," 5. "Culture jammers try to send counter messages into the public to intervene in the existing regime of truth, to challenge the general politics of truth, to challenge what counts as true with other truths or real truths that are otherwise obscured by mainstream discourses of power."

75. Gilman-Opalsky, 6. "Changing the codified meanings of things is an intervention; it is a form of praxis. Culture jammers change the meanings of their hijacked source materials; that is often their primary form of intervention."

76. Thomas Dekeyser, 2016. "Distorting Urban Habits: Subvertising and the Re-engineering of Urban Affect." Association of American Geographers lecture. "Positions subvertising as an attempted intervention into habitbodies where it may function as an external 'event that undoes

the holding together that habit performs' and may offer the ground from which habitual actions 'can resurface in consciousness where action can be evaluated and recalibrated.'"

77. Gilman-Opalsky, "Unjamming the Insurrectionary Imagination," 15.

78. Dekeyser, "Distorting Urban Habits." Dekeyser describes the three challenges subvertisers face: "Firstly, subvertisements may easily be ignored if the habitual passive interaction with advertising space is too strong. Secondly, the progression of habit-evaluation and modulation takes time and may require both persistence and patience. This means they require disruptive triggers that are expressed across a broad multiplicity of spatiotemporal assemblages. Thirdly, Bissell (2014: 489) has also pointed out how, at times, 'events of disruption become synthesised into habit's refrain' where the capacities of habit to absorb or neutralise future unwanted challenges to habitual modes of thought, feeling and behaviour are reduced. The result then of subvertisements might even perform an intensification of existing inclinations or refrains that thickens the 'protective guarantee' of urban habits rather than reducing their abilities to maintain in place."

79. Flood, *British Posters*, 82.

80. Including what it considers to be "art-washing," where individual companies will allow art to be displayed in their sites for a limited period of time, but ultimately retain control over those sites.

81. Guy Debord, "For a Revolutionary Judgment of Art," *Situationist International Anthology* (Berkeley: Bureau of Public Secrets, 1981), 310–14.

82. Gilman-Opalsky, "Unjamming the Insurrectionary Imagination: Rescuing Detournement from the Liberal Complacencies of Culture Jamming," 15. "If the new activism is led by a small cast of celebrity activists, including maybe 100–1,000 assistant workers behind the scenes, culture jamming becomes a voyeuristic politics, where very few do while most continue to watch."

83. Stephanie Boland, 2015. "How Special Patrol Group Are Encouraging the Public to Hack Advertising Space." *New Statesman*. http://www.newstatesman.com/politics/media/2015/09/how-special-patrol-group-are-encouraging-public-hack-advertising-space

84. Seiler, Research interview.

85. Seiler.

86. Stop TTIP, 2016. "700 Affiches Publicitaires Remplacées par un Message anti-TTIP."
https://www.youtube.com/watch?time_continue=1&v=_y2ikdev-P0

87. Posters, "Advertising Shits in Your Head," 16. "To build the movement, we now run workshops showing other people how to intervene and take back these spaces."

88. Brandalism, 2014. "A Guide to Interacting with Bus Stop Advertising Spaces." http://www.brandalism.org.uk/resources.

89. Special Patrol Group, 2015. "Total Propaganda."
https://www.youtube.com/watch?v=dbW2WiNCeWg&sns

90. Seiler, "Advertising Takeovers Practical Workshop Public Ad Campaign Daily."

91. Taken from "Brandalism" in the book *Cut It Out* by Banksy (2004), inspired by an article by Sean Tejaratchi, "Death, Phones, Scissors" *Crap Hound* no. 6 (July 1999).

92. Dr. D. 2014. "An Idiots Guide to Flyposting," *STRIKE! Magazine*, no. 8 (November–December 2014): 16–17.

93. Boland, "How Special Patrol Group Are Encouraging the Public to Hack Advertising Space."

94. Jordan Seiler, 2009. "New York Street Advertising Takeover."
http://www.publicadcampaign.com/nysat/
"It should be noted that between the two NYSAT projects, 9 people were arrested spending a total of 310 hours in jail collectively. Despite all cases being dismissed, we still cannot thank these participants enough for their sacrifice."

95. David Graeber, 2011. "Interview With David Graeber," *The White Review*.
http://www.thewhitereview.org/interviews/interview-with-david-graeber
"Well the reason anarchists like direct action is because it means refusing to recognise the legitimacy of structures of power. Or even the necessity of them. Nothing annoys forces of authority more than trying to bow out

of the disciplinary game entirely and saying that we could just do things on our own. Direct action is a matter of acting as if you were already free."

96. Seiler, Research interview.

97. Named after the American blues musician.

98. Day Against Ads, 2015.
http://dayagainstad.org/on-march-25th-2016-lets-clean-up-the-planet-ofads/ "Why March 25th? This is the anniversary of a French court decision confirming the legitimacy of our common struggle. On 25 March 2013, a constitutional court judge found a group of anti-advertising activists from Les Déboulonneurs group not guilty of 'degradation.' The group had publicly and symbolically spray-painted advertising billboards in 2009, but they were acquitted in the name of 'freedom of speech' and 'reason of necessity' against advertising oppression. This historic 2013 ruling can act as a call to action for all those around the world seeking to challenge the role of corporate advertising in our lives."

99. Bx1, Brussels Media, 2016. "The STIB and JCDecaux File Complaints against X after Anti-TTIP Wild Display."
http://bx1.be/news/la-stib-etjcdecaux-portent-plainte-contre-xapreslaffichage-sauvage-anti-ttip/

100. Adam Smith-Anthony and John Groom, 2015. "Brandalism and Subvertising: Hoisting Brands with Their Own Petard?" *Journal of Intellectual Property Law & Practice* 10, no. 1.

101. Jordan Seiler, 2016. Research interview. Vyvian Raoul.

102. Seiler.

103. Seiler.

104. Jordan Seiler, 2014. "Public Access."
http://www.publicadcampaign.com/PublicAccess/Index.html.

105. Dekeyser, T., 2016. "Robert Montgomery: Public Subvertising as Intimate Poetry." *Distorted Space*.
https://distortedspace.com/2016/08/02/robert-montgomery-public-subvertising-as-intimate-poetry
Other subvertisers, such as Robert Montgomery, have been criticised for their aesthetic similarity to advertising: "His work never truly appears as

nonadvertising at first sight; the typography forms and narrow spacing are fashionable, the white-on-black aesthetic equally.

106. Jordan Seiler, 2009. "New York Street Advertising Takeover." http://www.publicadcampaign.com/nysat

107. Jordan Seiler, 2010. "Toronto Street Advertising Takeover." http://www.publicadcampaign.com/tosat

108. Jordan Seiler, 2010. "Madrid Street Advertising Takeover." http://www.publicadcampaign.com/masat

109. Posters. Research interview. Vyvian Raoul.

110. Posters. Research interview.

111. Posters, "Advertising Shits in Your Head," 16. "How could we, as creative people, help re-democratise public space and share alternative messages about the social and environmental injustices caused by consumerism? How can we break their monopoly over message and meaning in public space?"

112. Posters, "Advertising Shits in Your Head," 17. "Internationally recognised artists were involved, but on the street you wouldn't know it: all the words were unsigned and anonymously installed within public space, as gifts to society."

113. Posters, 2016. "Round 1/The 48 Sheet/2012," Brandalism. http://www.brandalism.org.uk/project2012

114. Posters, "Round 1/The 48 Sheet/2012."

115. Brandalism, 2015. "Brandalism at COP 21/Paris/2015." Brandalism. http://www.brandalism.org.uk/brandalism-cop21

116. Brandalism, 2016. "Switch Sides Brandalism." http://www.brandalism.org.uk/switchsides

117. *STRIKE! Magazine*, 2015. "Total Propaganda." http://strikemag.org/total-propaganda
"To redress the balance a bit, we came up with our own posters. They're available for you to freely download and distribute—help us spread the word and print yourself out some counter-propaganda today!"

118. *STRIKE!*, "Total Propaganda."

119. RTUK, 2015. 'Bullsh*t Jobs' posters on the tube.
https://www.youtube.com/watch?time_continue=2&v=E-tIAlRgNpc

120. Alex King, 2015. "Anarchists Subvert London Billboards to Shout: Don't Vote," *Huck*.
http://www.huckmagazine.com/perspectives/activism-2/activists-subvert-london-billboards-shout-dontvote

121. Boland, "How Special Patrol Group Are Encouraging the Public to Hack Advertising Space."

122. Andrew Dolan, 2016. "The Ad Hackers," *Red Pepper*, August–September 2016.

123. Hogre, 2017. Research interview. Vyvian Raoul

124. Hogre. Research interview.

125. Contest Royalty, 2017 "Royal Shit"
http://contestroyalty.blogspot.com

126. Caroline Caldwell, 2017. Research interview. Vyvian Raoul

127. Caldwell. Research interview.

128. In part, inspired by The Center For Artistic Activism's webinar series, particularly the episode "How to Learn from Hollywood"
https://c4aa.org/2017/04/how-to-win-14-learn-from-hollywood

129. RJ Rushmore, 2017. Research interview. Vyvian Raoul

130. Art in Ad Places, 2017. Research interview. Vyvian Raoul

132. Art in Ad Places. Research interview.

133. Art in Ad Places.

134. Art in Ad Places.

135. Art in Ad Places.

VYVIAN RAOUL

Vyvian Raoul is a writer and an editor at Dog Section Press.

MATT BONNER

Matt Bonner is a graphic artist, designer, and social justice campaigner based in London.

JOSH MACPHEE

Josh MacPhee is one of the founders of the Interference Archive, organizes the Celebrate People's History Poster Series, and is a member of both the Justseeds Artists' Cooperative and the Occuprint collective.

ABOUT PM PRESS

PM Press was founded at the end of 2007 by a small collection of folks with decades of publishing, media, and organizing experience. PM Press co-conspirators have published and distributed hundreds of books, pamphlets, CDs, and DVDs. Members of PM have founded enduring book fairs, spearheaded victorious tenant organizing campaigns, and worked closely with bookstores, academic conferences, and even rock bands to deliver political and challenging ideas to all walks of life. We're old enough to know what we're doing and young enough to know what's at stake.

We seek to create radical and stimulating fiction and non-fiction books, pamphlets, T-shirts, visual and audio materials to entertain, educate, and inspire you. We aim to distribute these through every available channel with every available technology—whether that means you are seeing anarchist classics at our bookfair stalls, reading our latest vegan cookbook at the café, downloading geeky fiction e-books, or digging new music and timely videos from our website.

PM Press is always on the lookout for talented and skilled volunteers, artists, activists, and writers to work with. If you have a great idea for a project or can contribute in some way, please get in touch.

PM Press
PO Box 23912
Oakland, CA 94623
www.pmpress.org

PM Press in Europe
europe@pmpress.org
www.pmpress.org.uk

FRIENDS OF PM PRESS

These are indisputably momentous times—the
financial system is melting down globally and the
Empire is stumbling. Now more than ever there is a
vital need for radical ideas.

In the years since its founding—and on a mere
shoestring—PM Press has risen to the formidable challenge of publishing
and distributing knowledge and entertainment for the struggles ahead.
With over 300 releases to date, we have published an impressive and
stimulating array of literature, art, music, politics, and culture. Using every
available medium, we've succeeded in connecting those hungry for ideas
and information to those putting them into practice.

Friends of PM allows you to directly help impact, amplify, and revitalize
the discourse and actions of radical writers, filmmakers, and artists. It
provides us with a stable foundation from which we can build upon our
early successes and provides a much-needed subsidy for the materials that
can't necessarily pay their own way. You can help make that happen—
and receive every new title automatically delivered to your door once a
month—by joining as a Friend of PM Press. And, we'll throw in a free
T-shirt when you sign up.

Here are your options:

> **$30 a month** Get all books and pamphlets plus 50% discount on all
> webstore purchases

> **$40 a month** Get all PM Press releases (including CDs and DVDs)
> plus 50% discount on all webstore purchases

> **$100 a month** Superstar—Everything plus PM merchandise, free
> downloads, and 50% discount on all webstore purchases

For those who can't afford $30 or more a month, we have Sustainer Rates
at $15, $10 and $5. Sustainers get a free PM Press T-shirt and a 50%
discount on all purchases from our website.

Your Visa or Mastercard will be billed once a month, until you tell us to
stop. Or until our efforts succeed in bringing the revolution around. Or
the financial meltdown of Capital makes plastic redundant. Whichever
comes first.

Signal:01 The Taller Tupac Amaru ● Dutch Red Rat Comics ● Graffiti Writer IMPEACH ● Anarchist Imprint Logos ● The Graphics from Mexico 1968 ● Adventure Playgrounds: A Photo Essay ● Anarchist Designer Rufus Segar **Signal:02** Japanese Anarchist Manga ● *Freedom*: Anarchist Broadsheets ● Oaxacan Street Art ● Røde Mor: Danish Collective ● Revolutionary Murals of Portugal ● Malangatana: Revolutionary Mozambican Painter ● Gestetner Printing **Signal:03** South Africa's Medu Arts Ensemble ● Paredon Records ● Anarchist-Communist Prints ● Graphics from the 2012 Québec Student Strike ● Spanish Anarchist Newspapers' Mastheads ● Yugoslav Partisan Memorials

"If you are interested in the use of graphic art and communication in political struggles, don't miss the latest issue of *Signal*."

—Rick Poynor, *Design Observer*

Signal:04 *Palestinian Affairs* Magazine ● Street Art concerning the Juárez Femicides ● Antimilitarist Peace Navy ● Toronto's Punchclock Press ● New Zealand Political Posters ● Kommune 1: Berlin's 1960s Counterculture ● Three Continents Press **Signal:05** Emerging Print Collectives ● Displacement in Barcelona ● Political Prints from 1970s Uruguay ● NYC's Come!Unity Press ● Italian Political Records ● The Pyramid as Symbol of Capitalism **Signal:06** Stickers from the German Antifa, 1970s Portugal, and the IWW ● Appalachian Movement Press ● Mexican Collectiv ECPM68 ● 1970s Asian American Resistance ● Lebanese Collective Jamaa Al-Yad ● Incite! Anti-Imperialist Collage All issues available from PM Press ● PO Box 23912 Oakland, CA 94623 ● www.pmpress.org